Japanese Ink Painting

The Art of Sumi-e

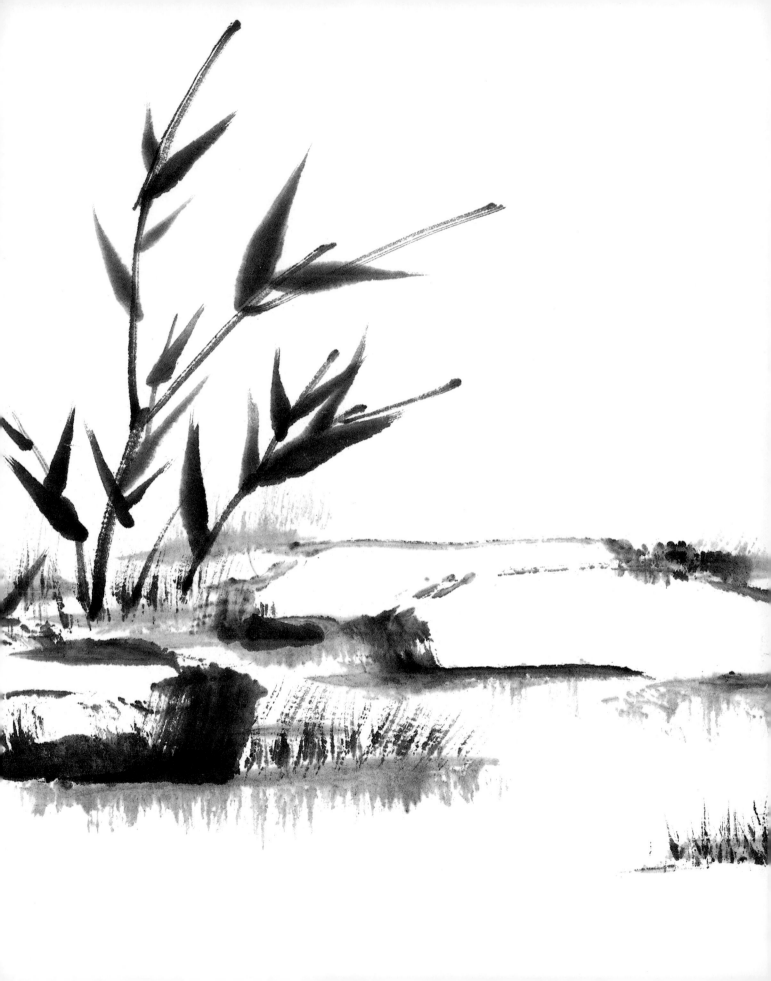

Japanese Ink Painting

The Art of Sumi-e

Naomi Okamoto

Sterling Publishing Co., Inc. New York

Library of Congress Cataloging-in-Publication Data

Translated by Elisabeth E. Reinersmann

Okamoto, Naomi, 1951–
 [Japanische Tuschmalerei für Einsteiger. English]
 Japanese ink painting : the art of sumi-e / Naomi Okamoto.
 p. cm.
 Includes index.
 ISBN 0-8069-0832-7
 1. Sumie—Technique. I. Title.
ND2462.03813 1995
751.4'252—dc20 94–40844
 CIP

10 9 8 7 6 5 4 3 2 1

Published 1995 by Sterling Publishing Company, Inc.
387 Park Avenue South, New York, N.Y. 10016
Originally published by Augustus Verlag Augsburg
under the title *Japanische Tuschmalerei für Einsteiger:
Ein Malkurs in Beispielen*
© 1993 by Weltbild Verlag GmbH, Augsburg
English translation © 1995 by Sterling Publishing Co., Inc.
Distributed in Canada by Sterling Publishing
% Canadian Manda Group, One Atlantic Avenue, Suite 105
Toronto, Ontario, Canada M6K 3E7
Distributed in Great Britain and Europe by Cassell PLC
Villiers House, 41/47 Strand, London WC2N 5JE, England
Distributed in Australia by Capricorn Link (Australia) Pty Ltd.
P.O. Box 6651, Baulkham Hills, Business Centre,
NSW 2153, Australia
Printed and bound in Hong Kong
All rights reserved

Sterling ISBN 0-8069-0832-7

CONTENTS

INTRODUCTION

Some time ago, I decided that I wanted to write a book about Japanese ink painting, also known as *sumi-e*. In the beginning, I thought I would first develop my own style and use the pictures I painted in that style as a means of introducing the art of Japanese ink painting to people of other cultures. Even though many thought this couldn't be done, I believed it was possible by pointing to what Japanese ink painting has in common with other styles of painting and by paying attention to our subjective impressions. After all, painting is basically an immediate expression of the subjective; human feelings are not all that different. Besides, the spontaneous, expressive character and the visual aesthetics of ink painting make it very accessible to the modern Western viewer. I believe that *sumi-e* will continue to seem strange as long as we try to understand it strictly from an intellectual, theoretical point of view. In addition to its subjective sensitivity, its grace and beauty (still of great significance in the Japanese culture) could be the common ground on which to meet. I am convinced that whatever seems foreign in ink paintings can be overcome by discovering their inherent beauty.

A Japanese philosopher once said, "Beauty is not only what looks cheerful; rather, it is the result of a mental process. Beauty is a gift of life, present every day, giving joy and hope to life. It expresses the character of the artist; it is love. This subjective understanding of the aesthetics of beauty has always been at the heart of my work, as a student of Western painting and even before I began my intense involvement with ink painting. I am constantly trying to increase my understanding of the secret of beauty."

All this started when I realized that in the absence of artistic skills and beauty, painting as it is presently practised in the West can only be seen as an expression of eccentric ideas and a depiction of problems, such as the portrayal of the superficial. On the other hand, I am aware that in the West, too, people long for quiet, freedom, harmony, and beauty as antidotes to the alienation so prevalent in our technological society. In spite of the fact that our cultural backgrounds are different and that you approach art from a different viewpoint, you, too, are fascinated by the clear forms that are created in the emptiness of space, conveying the presence of eternal quiet. Regrettably, I have been unable to find my own form of expression. Nevertheless, I have been able to create paintings true to Japanese culture by incorporating individually what seemed unfamiliar and by transforming and blending it with the traditional. In order for you to gain access to this style of painting, you will need clear instructions. I believe that it would be helpful for me to share with you the experiences and insights I have gained. They will serve as guides as you continue to develop your art. I like to compare this process to a growing bamboo tree that develops new nodules as it grows.

In this spirit, the knowledge of *sumi-e* that I have gained so far is contained in this book. It is my wish that the discussions that follow be received by your heart. I hope you will be able to develop a sense of the intuitive process as you become more and more familiar with this art form.

Let's be on our way!

On the Way

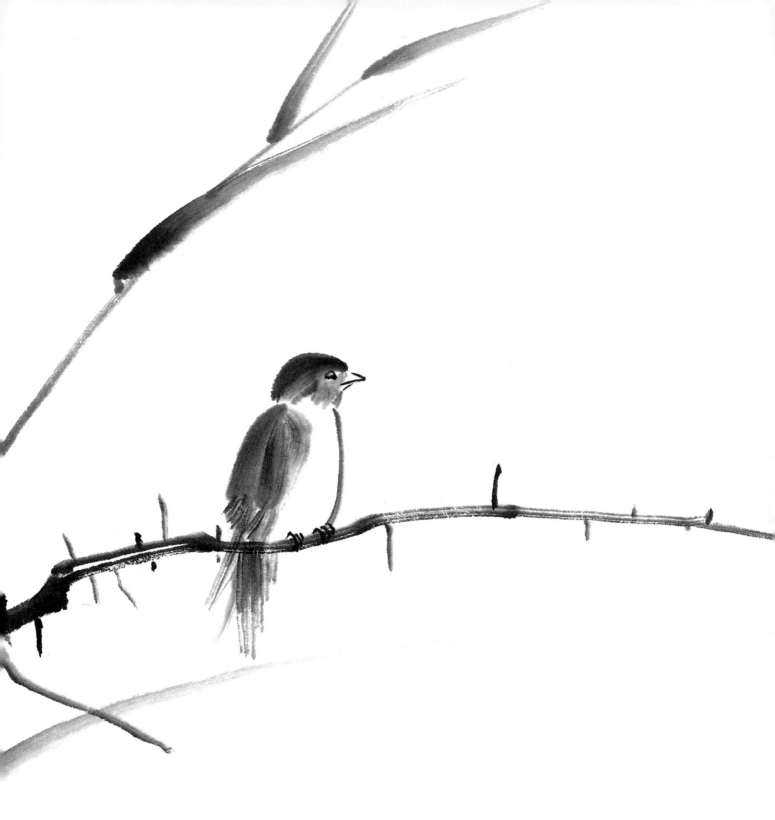

THE BASICS

Background and Essence of Japanese Ink Painting

In order to get a clear sense of what ink painting is all about, I think it is useful to look at the differences between this style and Western painting. The goal of classical Western painting is to depict the world and its objects as realistically as possible. To achieve that goal, it has developed a precise structure of foreground, background, and central object, creating a three-dimensional perspective. This style of painting needs light, shadow, and, most of all, color. Ink painting uses none of these aids. Even though it, too, depicts a view of the world, its goal is not to produce a realistic picture of it, but rather an expression of the perception a painter wants to convey. It is an attempt to capture, in condensed form, the essence of an object, a person, or a landscape as seen through the eyes of the painter. For that reason, *suggestion* plays a key role. Suggestion and simplification in a painting imply reality.

In Japanese ink paintings we see the traditional aesthetics of simplicity combined with a distinct emphasis on intuitive expression. A sense of harmony, so typical in Japanese culture, pervades every scene. This explains why paintings that de-

pict flowers, birds, and landscapes are so popular.

This style of painting, heavily influenced by Zen Buddhism, uses only black ink. However, according to Oriental understanding, black ink is not simply black. It has many different shades, representing the highest level of color simplification.

Different degrees in tone do not represent different shades of light or brightness; rather, they produce an awareness of color by creating a contrast with the white surface. This is what gives a painting the appearance of color. The tones also serve as an immediate expression of emo-

tions, mirroring the intensity of the interest the painter brings to the work. In a sense, it is the process that gives *sumi-e* its expressionistic character.

In addition, the white surface of the picture is not simply an open space left after the theme of the picture has been established, as is often the case in Western paintings. Instead, it is an essential part of the picture. White surfaces come alive and gain depth when they become one with an object and a technique, creating a form.

For example, suppose that as you watch a wild flower your heart is

touched by its vitality. As the radiance of the ink is transferred to the paper with the stroke of a brush, the flower in your picture seems to "breathe," and this breath begins to fill the white space surrounding it, just as it does in nature. In ink paintings, a line does not represent the contour or the outer edge of a form; rather, it represents the inner power of the painted form itself. It represents soul, spirit, and life rhythm all at once.

After this art form arrived in Japan from China, it was heavily influenced by Taoism and especially by Zen Buddhism. The concept of

"white space" is a direct expression of Taoism and Zen Buddhism. The understanding of movement, of the "real" flowing and dissolving into "nothingness," and the existence of "emptiness" are of central significance to both beliefs.

The essential character of ink painting, expressing the dynamics of life, is, quite possibly, a foreign concept for Western artists, because you have to become one with the object in the painting. In Western paintings, you are not the flower. However, picture yourself painting outside. Sense the rays of the sun on your skin; let your eyes gaze into

the distance. This is a moment when you begin to become one with the flower.

Or think of music. Landscapes, birds, and rocks are notes created in nature. First you study the notes, next you practice on your instrument, and then your emotions play these notes.

When you experience how the gentle, tender shades of the ink and a simple line, created from a state of inner quiet, are transformed and express the most powerful energy, you will have a sense of what these philosophies are all about.

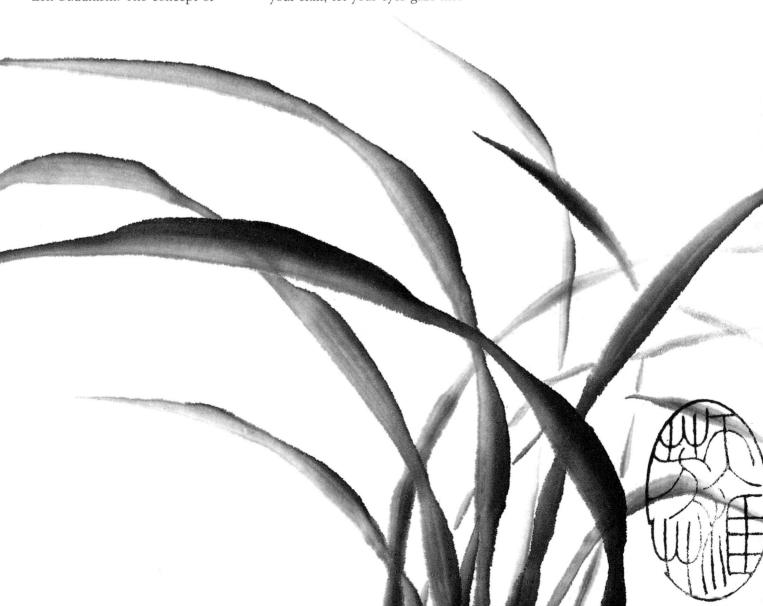

Painting Utensils

Nothing is complicated about the materials necessary for ink painting, and they are inexpensive. Here is a short list:

Utensils:

1. *paintbrush*
2. *ink stone or grinding stone*
3. *ink stick*
4. *water bowls*
5. *cotton cloth*
6. *plate*
7. *paperweight*

The Brush

A supple brush allows you to express in visual form almost anything your heart can feel. The type of brush and the way it is used allow you to express many different nuances in one line, something not possible with ordinary brushes. You can create different tonal values as well as change the shape or form, all within one stroke. It is true that a watercolor brush made from marten hair can also be quite handy. However, this type of brush, because of its construction, does not hold enough ink and is too springy for ink painting.

It is important to use brushes specifically made for *sumi-e,* because these give you a greater range of expression than other brushes. However, in a pinch, it is okay to use a calligraphy brush.

Painting and calligraphy brushes made in the Orient come in different shapes, lengths, and types of hair. Goat, sheep, horse, badger, deer, weasel, bear, wolf, and rabbit hair are used. Usually white-haired brushes are made from sheep, goat, and horse hair. Brown-haired brushes are made from horse, badger, bear, weasel, wolf, and deer hair. Hair from the summer fur of all animals is stiffer than that from winter fur. Sheep and goat hair are both considered soft. Somewhat stiffer is hair from the weasel and badger. Considerably stiffer is hair from mountain horses.

Brushes made from soft hair are

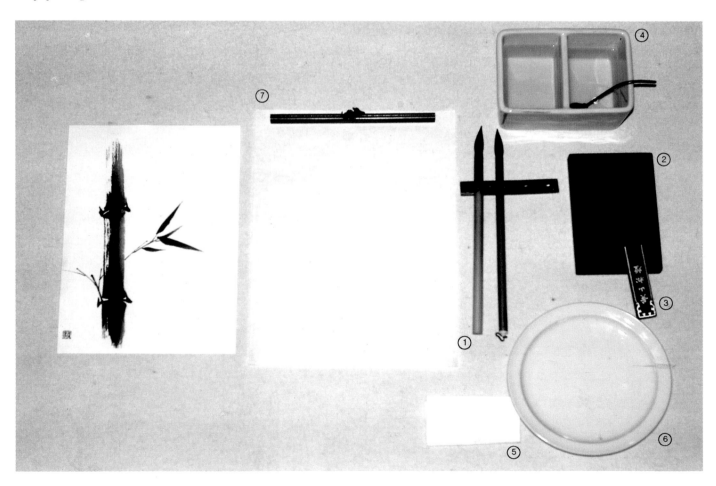

more difficult to handle. Therefore, I recommend that beginners use a stiffer brush. Although many different brushes on the market often look tempting, I always come back to the brush that allows me to create shapes ranging all the way from a thin hairline to a broad stroke.

Japanese Choryu Brush

This is one of the traditional ink brushes. Usually, it is made from sheep or goat hair; occasionally, somewhat stiffer badger, horse, or deer hair is used. This brush has soft, pliable bristles and a good ability to hold water. However, because of its softness, the shape of a line may change when pressure is applied to the surface. Because of a brush's excellent absorbency, it is often difficult to control the amount of water in the bristles.

Japanese Maruyama Brush (Gyokuran)

Usually, this brush is made from the belly hair of a horse with an addition of badger, sheep, and deer hair. It is firmer than the Choryu and has a slight point, making it ideal for creating shapes. However, this brush is not yet available in all areas.

Chinese Ran-chiku Brush

This brush, made from badger hair, has less capacity to hold water and is somewhat stiffer than the two brushes discussed above. It is well suited for creating shapes in rough outline and for strong, bony outlines.

All three brushes discussed here come in three different sizes. The length of the hair is 1½ inches (4 cm) for large brushes, 1⅓ inches (3.5 cm) for medium brushes, and about 1 inch (3 cm) for small brushes. The smallest of the three is very handy but, because of its size,

tends to lose ink very quickly. Because the ink has to be replaced more frequently, there is often an uneven and "restless" appearance to the painting. On the other hand, the largest brush is not quite as easy to handle. However, it is possible to draw with it the very finest line and to fill in large spaces. Additionally, this brush lasts for a long time. In the beginning, we are interested in learning to master the tools. I believe we learn faster when a tool is not quite as easy to handle. Thus, I recommend that the beginner start with the largest brush.

The bristles of a new brush are covered with a coat of glue. This coating is removed by dipping the brush in cold water and squeezing the bristles gently between the fingers. Soap is not necessary. Do not leave the brush standing in water, or the bristles will bend and separate from the shaft. After the glue has been removed from the bristles, gently shape the end of the brush into a tip. Let the brush dry by laying it down or by hanging it with the bristles pointing downwards. When the bristles are dry, store the brush in a place where it will receive some air and make sure it is protected against moths.

When you purchase a new brush, a sleeve covers the bristles. This sleeve is only protection and not meant for permanent use.

Grinding Ink

The best ink for ink painting is made from pigments that are pressed into a stick. The stick is ground, combined with water, and mixed into a usable liquid. Ink stones, or grinding stones, come in different shapes, from round to oval to rectangular. For the beginner, an

ink stone that is approximately 3 by 5 inches (8 by 13 cm) and deeper on one end is very practical. Most stones are made from a particular kind of slate and are of different quality, depending on the grid of the surface. The most famous stone is the Chinese Tan-kei.

If the surface of the stone is too rough, the pigment particles from the stick will not dissolve properly, and the ink loses its brilliance.

Ink—The Liquid Produced from the Ink Stick

The soul of the ink is the power of its brilliance and its rich nuances. Sumi-e primarily distinguishes between blue and brown ink sticks. The so-called blue ink is made from the soot of burned pine wood. In the process of burning, blue ink sticks are contaminated with rough particles that leave scratches on the surface of the ink stone. However, this also increases the amount of nuances in blue ink. The finer, softer brown ink does not have as many nuances. Because blue ink doesn't reflect light very well, it appears to be black with a blue hue. Blue ink is very popular in Japan. Brown ink is usually produced from the soot of rapeseed oil. The pigment particles are much smaller than those in blue ink and reflect more light. This ink has a brown tint and seems to be warm and lively. Chinese painters and calligraphers are very fond of brown ink.

In addition to pigment particles, ink sticks also contain animal fats that are used as glues. These animal fats absorb humidity very quickly, which makes them susceptible to mildew, rendering them useless. It is impor-

tant to dry and wrap an ink stick after it has been used. Ink sticks are highly sensitive. They can dry out, become brittle, and even burst apart. Because of the fat content, if a stick remains moist for a long period of time, it will stick to a surface, for instance that of the ink stone. The stone must always be cleaned under running water. Make sure that all ink particles are removed.

Do not use liquefied ink that has been standing around for some time, because the pigment will separate from the water. This can happen relatively quickly during the summer. Old ink becomes dull and loses its brilliance. Always start fresh if any length of time has elapsed between painting sessions.

In addition to the two types of inks discussed so far, there are ready-made liquid inks available. They are less expensive than ink sticks and require no preparation time. These inks are usually used in calligraphy, where only the most intense shades are needed. Pigment particles in ready-made liquid ink are larger than those in ink made on an ink stone, but for that reason they are less reflective and appear to be truly black. This ink is void of all nuances. When compared to ink made on an ink stone, this type of ink appears to be less three-dimensional and, therefore, flat.

If your goal is to discover the soul of ink painting, I strongly recommend that you grind your own ink. The process seems cumbersome, but the monotony of grinding as part of the preparation is helpful in gaining valuable inner quiet. During the process of grinding, you might want to visualize the picture that is to be painted. As you will quickly discover, the actual process of painting must proceed without hesi-

tation. Corrections are almost impossible to make afterwards. For that reason, it is important to know precisely what and how you want to paint before you reach for the brush.

The intense brilliance of the ink is the medium with which you transfer your own energy into the painting. Its varied shadings are the expression of your heart. Do you want to exchange these for the sake of convenience?

Additional Aids

Water Containers

You need a container to clean your brushes and a container to grind the ink. Make sure these containers don't have sharp edges that could damage the bristles of your brushes. Furthermore, the containers have to be absolutely free of any grease. When fat comes in contact with bristles, the bristles separate, and the brush loses its tip. In addition, it becomes difficult to achieve subtle shading.

Cotton Rags

A cotton rag allows you to control the amount of liquid in your brush. Immerse the rag in water and wring it out well. It is easier to control the amount of ink in your brush with a damp rag than with a dry one.

White Plate

A white plate is used to dilute and mix different shades of ink. A white plate is used because it is easy to see the shape of the tip of the brush and to judge the intensity of ink on a white surface. In order to have enough space to work, use a plate that measures at least 6 to 8 inches (15 to 20 cm) in diameter.

Pad

The best material to use for a pad is felt. However, you can also use an old piece of a rug. Since the ink-water mixtures you use are easily absorbed by the relatively thin paper, a harder surface would create puddles on the surface of the pad, and that is not very helpful. Furthermore, a hard pad makes it more difficult for delicate bristles to move across the paper, causing the ink to run sideways.

Paperweight

A paperweight is necessary to keep the paper in place. In lieu of a paperweight, you can also use small rocks, a metal weight, or any other suitable item.

The Painting Surface— Characteristics and Effects

Paper

The paper used for ink paintings is somewhat difficult to handle. The fact that it is cumbersome to transport and to store increases its cost. In the past, paper for ink painting has been difficult to come by in the West, particularly if a painter had certain requirements. However, things have improved, and paper from China and Japan is now more readily available. Paper made specifically for ink paintings is as valuable in Asia as handmade paper is.

Finding the right paper is difficult. The number of manufacturers that make paper for ink painting is relatively small and, because many different "recipes" are used, there are many types of paper on the market. Since ink is very sensitive and reacts differently to varying degrees of humidity, don't expect the same

results from the same brand of paper. In addition, because of concerns for the environment, other raw materials are now being added during the manufacturing process. Even if the brand name of a paper has not changed for hundreds of years, it is not a given that the product has not changed. So, select the best from what is available.

Paper made for *sumi-e* is available sized, untreated, and in different thicknesses. If a paper is rough and feltlike, the ink disperses rapidly and appears dull and lifeless. If, on the other hand, too much sizing has been applied to the paper, it will be smooth and shiny. On this type of paper, ink will collect in puddles, be absorbed only slowly, and leave unintended dark spots and edges.

Watercolor paints, however, retain more of their brilliance on this paper than they would on a more ab-

The effects of ink on different types of paper

a) *Paper that has been heavily sized*

b) *Japanese paper with minimum sizing*

c) *Japanese rag paper*

d) Gasen-shi *paper*

e) *Blank newsprint*

f) *Paper for watercolor painting*

sorbent paper. The best paper for ink paintings retains the brilliance of the color of the ink as well as its transparency and the nuances of its shades.

Such paper is called *Gasen-shi*. It is available from Japan as well as from China. Traces of brush strokes remain visible on *Gasen-shi*. The different shadings and the brilliance of the ink are also apparent. Chinese paper is more absorbent than Japanese paper.

Two other favorite papers are *Kozo-shi* and *Ma-shi*. Brush strokes are not as easily visible on these papers, and they absorb water as quickly as a blotter. Both types of paper are particularly suited to painting in powerful, dry strokes or to painting in several layers.

If you are looking for nonabsorbent paper for detailed work, use the paper called *Torinoko-shi*. This paper has an eggshell color and a smooth surface. You can blend contours and create gentle transitions. However, you will sacrifice the intense, brilliant, and transparent qualities and the minute shadings of the ink. The paper is similar to fine-grained watercolor paper.

When in doubt, experiment with blank newsprint or absorbent computer paper. In general, always paint on the smooth side of the paper.

Paper or Silk

In the beginning, many ink paintings were done on silk. Silk prepared with a layer of glue is well suited for painting fine lines and details and for creating gentle transitions. For this reason, painters love to use silk when painting animals and birds (especially their fur and feathers) as well as landscapes shrouded in fog.

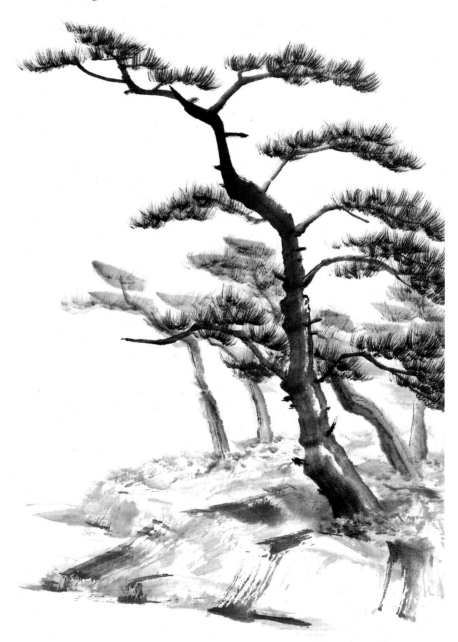

Pine tree on paper

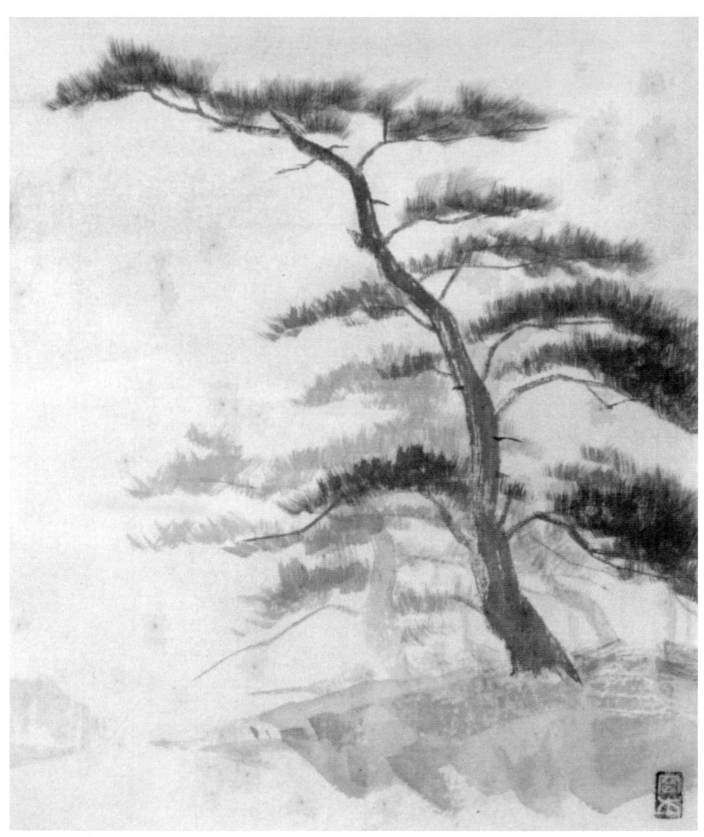

Pine tree on silk

Hohenzollern Castle
(on silk)

First, the whole surface was moistened with a large brush. Then, while the surface was still wet, the outlines were painted in ink, blending the contours immediately with a hard and dry brush. After the silk had dried, the rough contours of the castle were filled in with a fine-tipped brush. For this step, I used a very light shade of ink, filling in with darker shades those parts that

seemed particularly important. I blended the contours of the tree-tops in order to create movement, making it seem as if they were trying to reach out to the castle.

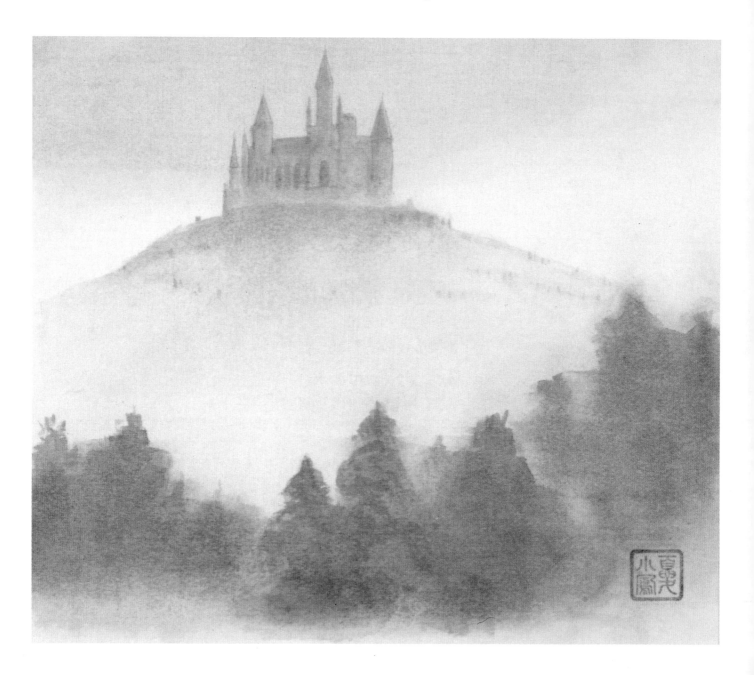

How Ink Behaves on Untreated Gasen-shi

Here are a few charming effects that can be achieved on *Gasen-shi*:

1. Dark ink painted on a wet, lighter shade of ink
2. Lighter shade of ink on a dark, wet ink
3. Light shade of ink added repeatedly
4. Traces left by a brush where the bristles have been spread out

The drawing below shows how individual petals are created by outlining them in lighter shades of ink. This separates them, creating a three-dimensional effect. The edges are painted by overlapping the ink, a little less when the ink is dark, a little more when the ink is lighter. This unusual effect, however, can only be achieved on untreated *Gasen-shi*.

Peony (on Gasen-shi)

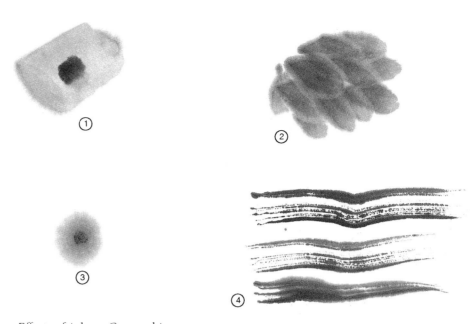

Effects of ink on Gasen-shi

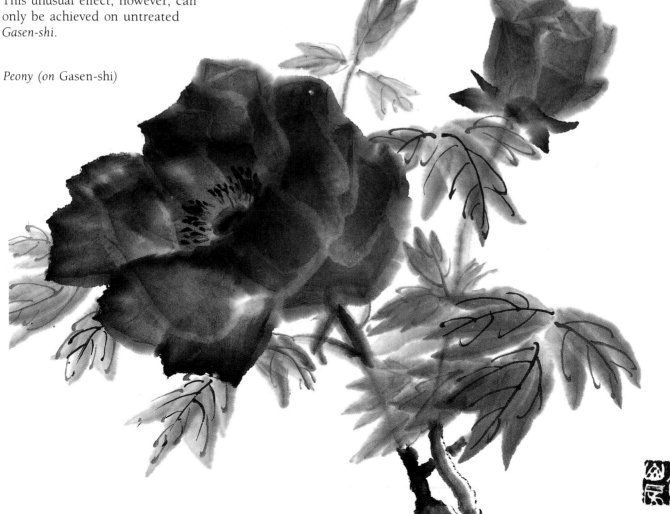

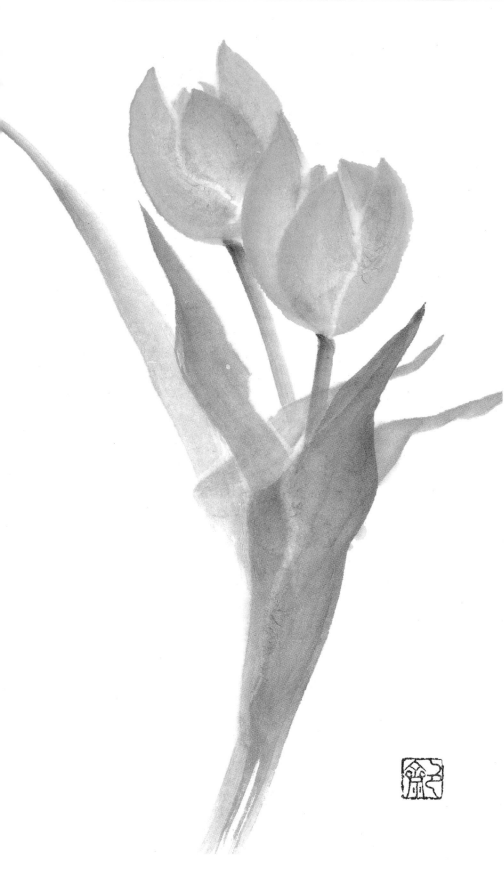

Working with Ink and Brush

Grinding and Preparing Ink

As already discussed, for best results, make your own ink, using an ink stick and ink or grinding stone.

Put a few drops of water on the shallow part of an ink stone. By the way, the shallow part is called "land" and the deep part is called the "ocean."

Stand the end of the stick upright in the water and move the stick in a wide, circular motion over the stone until you have an even, smooth liquid. Push this liquid into the deep part of the stone and repeat the procedure, adding water to the shallow end and grinding the ink stick over the surface of the stone. In this way, you prepare the darkest, blackest ink in highly concentrated form for use in mixing the many different shades. The success of your painting depends to a great degree on how well you have ground your ink! Ink that is too pasty will have lost much of its life.

Periodically, replenish the dark ink in the "ocean," because, over time, it will be diluted by wet bristles constantly dipped into it. It may also become pasty due to low humidity.

Tulips (instruction on page 40)

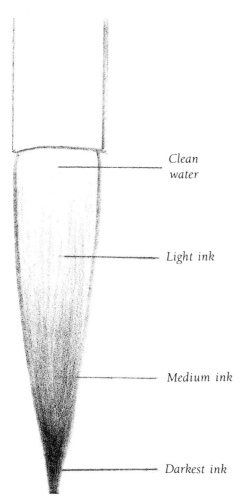

Clean water

Light ink

Medium ink

Darkest ink

Filling the brush with ink

Filling the Brush

Many beginners complain that it is hard to load a brush with ink. This complaint is not warranted. You are not supposed to rush. Rather, learn to be gentle when taking up ink. In other words, if you have a problem filling your brush, you simply are not taking enough time.

Try to follow these steps as closely as possible:

—Fill the whole brush with water.
—Adjust the amount by wiping the brush over a damp cotton rag. You need more water if the surface you intend to paint is large; for a small surface, you need very little. Always move the brush over the rag in the direction of the bristles.
—Dip the tip of the brush in the shallow portion of the stone and only take enough ink for the first third of the bristles to darken on one side.
—Spread the ink to the base of the brush by dragging the bristles lightly over the plate.
—If you notice that the ink becomes too light, repeat the process.
—Dip the tip of the brush into the darkest portion of the ink one more time.

To summarize the most important points:

—The ink on the stone should always have the most intense consistency. Diligence during the grinding process is absolutely necessary for success.
—Refill your brush as little as possible and paint as much as you can with each filling.
—Be patient when trying to determine the proper amount of wetness, for brushes have a great capacity to hold water.
—If you have lost patience, you will have lost it all.

Brush Control—How to Hold the Handle of a Brush

When we talk about holding and moving a brush, we distinguish among three things: the grip (or how to hold the handle of the brush); the direction the brush moves in relation to the painting surface, at an angle or vertically; and the way in which the tip of the bristles touches the surface. It is worth noting that it is less important how the brush moves than how the bristles make contact with the painting surface, and this depends largely on the pressure that is applied when painting. Different pressure creates different shapes.

Let's start with how to hold the handle of the brush. In the beginning, holding a brush will feel rather strange. If you hesitate, your painting strokes will look shaky and unsure. Therefore, hold the handle securely without interfering with the mobility of your hand. Don't stiffen up because the bristles of ink brushes are not as deeply anchored in the handle as are those on water-color brushes. Ink brushes are very smooth, particularly when they are held upright. This type of brush allows your inner emotions to be transferred directly to the paper.

There are two different ways to hold the handle, regardless of whether the brush is held vertically or on an angle. In the beginning, I recommend that you use the *Sokou* style. Later, when you have become more familiar with the technique, you can practice rotating the brush between your fingers. This is called the *Tankou* style.

Brush Technique

Sumi-e brush technique includes the position of the brush in your hand

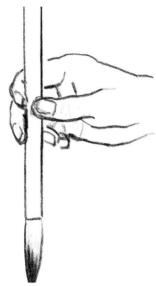

Sokou *grip*

Let the handle of the brush rest against your ring finger, holding it between the index and middle fingers. Keep it in place with your thumb. This will anchor the brush securely in your hand.

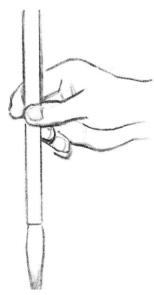

Tankou *grip*

Let the handle rest against your middle finger, while holding it between your index finger and thumb. This gives you great mobility. The middle finger can be used as support from behind.

and the method of applying ink to the paper. Learning to load a brush properly and using good brush movements will enable you to create ink in many different shades and to paint everything from dots to lines to spaces.

Holding the Brush at an Angle

When creating a space, the brush is brought in contact with the paper and moved over it at an angle. The tip of the brush is always kept in the same position. If the brush has been loaded in three distinct concentrations (light, medium, and dark ink), as outlined on page 19, a line will look like (a) on page 21. If you have dipped the brush into the water again, after it has been loaded, it will look like (b). The width of the painted line will depend on the length of the bristles that have been in contact with the paper. This can be changed by adjusting the pressure that is applied to the brush.

A line painted with the brush held at an angle will vary more in its width, have a more varied shading, and look smoother and more "emotional" than one that is painted with the brush held in an upright position.

Holding the Handle in the Vertical Position

If a brush is held vertically, the width of a line can be changed by varying the pressure applied to the brush (c). As the bristles bend, the tip remains on the center of the line. Such a line will look positive, strong, and powerful. The brush is moved from one side to the other. Use this technique when painting stems or twigs to create a clear, lively line (d), while keeping an even width.

If you want to change from painting a wider to a narrower line, rotate the brush between your fingers (around its own axis), reduce the pressure, and continue painting with the brush still in a vertical position (e).

Pushing the Brush Across the Paper

When you push the bristles of the brush across the paper and sense a certain resistance (as the bristles begin to bend), the line that is created will appear strong, powerful, and heavy. Very interesting textures within a line can be created. This movement is used for painting branches and tree trunks.

Let's summarize the most important points:

—Pressure, speed, and the wetness of the brush influence form and appearance. Take note of these three points and practice them until you are proficient. This technique is also very effective in controlling the flow of ink on the paper.
—If a brush is too wet, move it over the paper quickly and with very light pressure.
—If the brush is not wet enough, move it over the paper slowly and apply more pressure.
—The movement of your brush starts in your heart, goes through your arm, through your fingers, all the way to the tip of the brush. Don't rest your elbow on the table or the flow of this movement will be hindered.
—Try to paint with a "long breath," instead of many small broken lines. Try to outline objects in broad strokes, changing the movement of the brush as little as possible. Hesitating and painting in stop-and-go strokes disconnects you from the inner depth, influ-

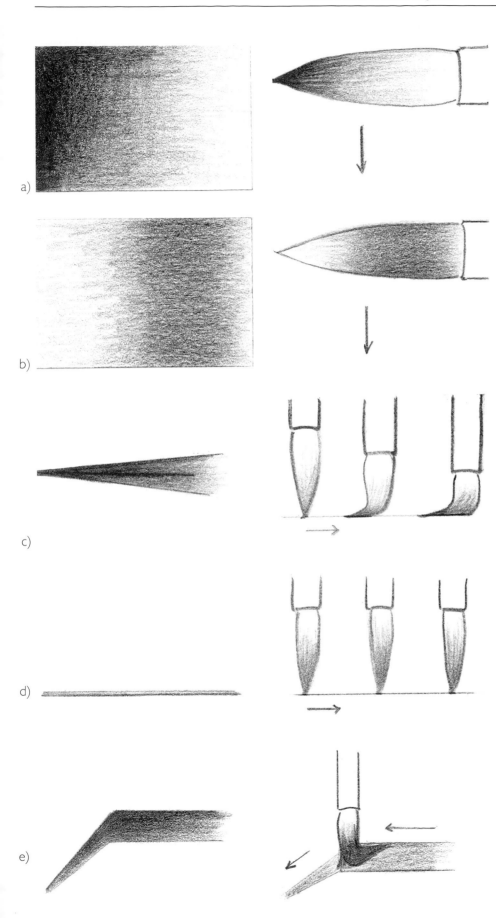

Brush techniques

encing the energy and harmony of the whole. Always know what you want to paint before you start. As soon as you take the brush in your hand, allow it to guide you. Let go of "thinking."

Learning to trust the process is difficult, but it also builds confidence.

—Every moment exists just once. This is also true for every line you paint. A brush is so sensitive, so agile that it mirrors every emotion, and, therefore, the same situation can never be repeated. Try to avoid correcting a line, or any other form for that matter. As often happens in our own lives, we lose if we ask for more.

—It is interesting to note that even your very first attempt has a certain kind of beauty, regardless of the technical shortcomings that are present. Therefore, if you try to make corrections in the belief that this will improve your technique, you will never paint a beautiful picture. It is much more important to let your vision come to life on the canvas from a place of inner peace and trust. I keep trying until I am satisfied. And it will happen, all of a sudden, usually when I have let go of my obsession with perfection.

I do not believe that this a coincidence. I always tell my students, "Each painting has its own beauty and each subsequent picture will be even more beautiful."

PAINTING TECHNIQUES

Practicing Lines

The First Line Will Become a Fish

This is an exercise in holding a brush vertically. The goal is to experience the special feel of working with ink brushes, paper, and ink. Blending water and ink on paper creates many different shades. In spite of the fact that ink is black, it is not a sober, cold, inorganic black, as is the case with the blacks of watercolor and oil paint. Ink has a particular kind of warmth; it breathes.

The Second Exercise: Orchids

This is an exercise in drawing a line with a certain kind of rhythm. When painting the leaves, the goal is to draw a curved line that looks as if it were brought to life by a long breath. It is carried out in a swift move, alternating the pressure that is applied to the brush. Practice from left to right and right to left until you feel that the brush is moving across the paper without any hesitation. Also practice alternating the speed with which you move the brush.

The Third Exercise: Bamboo

This is an exercise in holding the handle of the brush upright and at an angle. The goal is to practice drawing straight shapes and lines. Drawing a bamboo stem lends itself well to painting in different shades, taking up additional liquid, applying varying pressure, and choosing the proper speed.

When drawing leaves, experiment using different brush pressures.

When painting nodules and branches, practice drawing compact, strong, vigorous lines with the tip of the brush.

The Fourth Exercise: Plum-Tree Branch

Here you will practice strong curved and circular lines, using the tip of the brush. When pushing a brush across the paper, trying to create strong, rigid lines, speed and pressure are the important factors.

Practice until the ink creating the branches and twigs does not bleed too heavily into the paper.

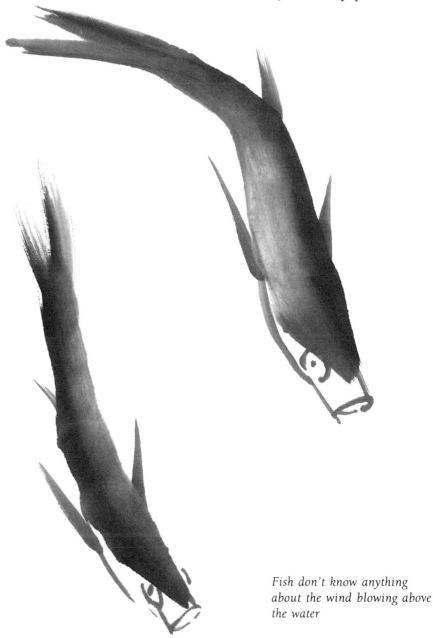

Fish don't know anything about the wind blowing above the water

Painting by Numbers

It is not easy to understand the way a totally foreign culture views its art. Even though, in the past, Western art schools taught artistic techniques by requiring students to copy old masters, experts today hesitate to teach "by the numbers." However, this is still the most effective teaching method in the Orient. This is particularly the case when unfamiliar techniques and aesthetics are being taught and when only a limited time is available. Under these conditions, I believe this method is a sensible and effective one. To be able to paint exactly as shown in the examples, you must already have mastered the techniques.

During my studies, the master teacher would paint a picture in our presence. We tried to duplicate his painting until the master said, "Good. Now I will paint the next example." In addition to learning through this method, reproducing an ink painting or a calligraphy is viewed differently in the Orient. In general, Japanese culture is shaped by adapting and incorporating foreign influences. The expression of original forms or ideas in the fine arts is not valued as highly in Japan as it is in some other countries. Much more important is the genuineness of what the artist is expressing and whether or not the artist touches the heart of the viewer. Of course, artistic creativity must also be present.

Your own emotional reaction and acceptance of the original precedes the act of copying, and the painting is your own, personal interpretation of it. Listening to the language of the brush gives expression to your internal voice.

I constantly come across people who are categorically opposed to this kind of learning and teaching method. They always say, "I must paint freely and simply experiment." I am amazed that people believe they already know what they must free themselves from and how to practice. However, it is not all that long ago that I entertained similar notions and freed myself from similar conventional thinking.

Steps for painting a fish

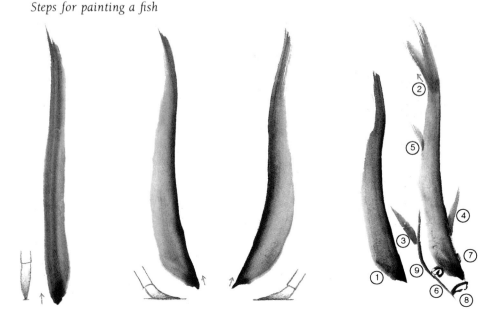

The First Stroke Becomes a Fish

I was sitting in front of a large piece of blank paper. My master reached for my hand and guided the brush, already filled with ink. "You don't have to be afraid," he said to me. Slowly, first the tip and then the body of the brush made contact with the paper. Ink and water began to flow onto the paper, and as they began to blend, the head of the fish appeared, then the body, and finally the tail, all created with a swift movement of the brush across the paper. I had an instant sensation—my feet, instead of the fish, had just touched the water. After the second fish was drawn on the paper, I sensed the spatial expanse that my master had created. This is how I experienced my first contact with creating an ink painting.

Hold in your mind's eye what your painting is supposed to be. This will allow you to experience the particular role that brush, paper, and ink play in ink paintings.

Body

First, load your brush with the three different shades of ink. If you hold the brush upright and draw a line, you will create a narrow body; if you hold the brush at an angle, a somewhat wider body with darker edges will emerge. Complete the body by drawing the second tail fin. Place the brush at the base of the tail and pull the brush swiftly towards and over the edge of the paper. Do the same with the side fins.

Eyes and Mouth

Control the wetness of the bristles so that the tip is drier and becomes

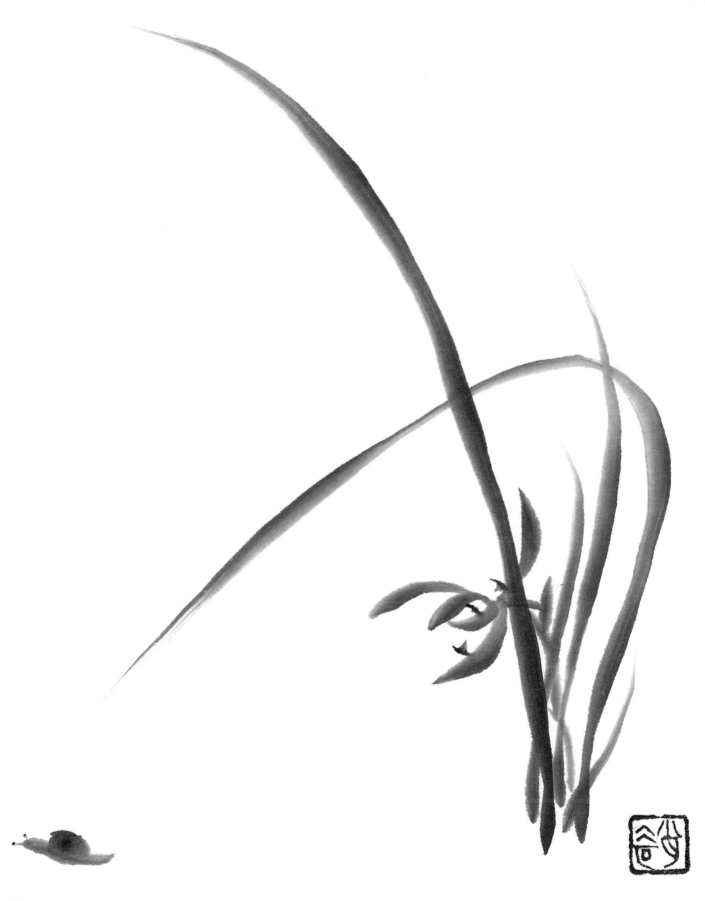

stiffer. This assures that the tip of the brush widens evenly. Draw the eyes and mouth with a strong line.

The Second Experiment: The Orchid

Many of the old masterpieces depicting orchids were painted by women. These graceful paintings are expressions of their hidden emotions. Behind the restrained, gentle forms of the orchid, women were hiding their pride and their passion. In the old days, people believed that the ink women used re-leased the fragrance of the orchid and that the ink stone itself was like an orchid field.

Leaves

Fill, or load, your brush and hold the handle upright. Start by applying pressure only at the tip of the bristles, so that the stem of the leaf looks as if it were rooted in the earth. Feel the force of movement in the tip of the brush. This represents the energy of growth. Use it to create the lines that will become the whole leaf. Continue to pull the brush slowly over the paper, alternating the pressure. First reduce the pressure, then increase it, and then reduce it again. Draw with this rhythm, concluding with a soft curve. At the end of the leaf, the brush is pulled across and beyond the paper as if its tip were reaching gently into the distance.

The second line, the second leaf, crosses over the first. The third line crosses over both the first and the second, creating a counterbalance to both. Add the fourth line. Crossing the lines creates space.

Steps for painting an orchid

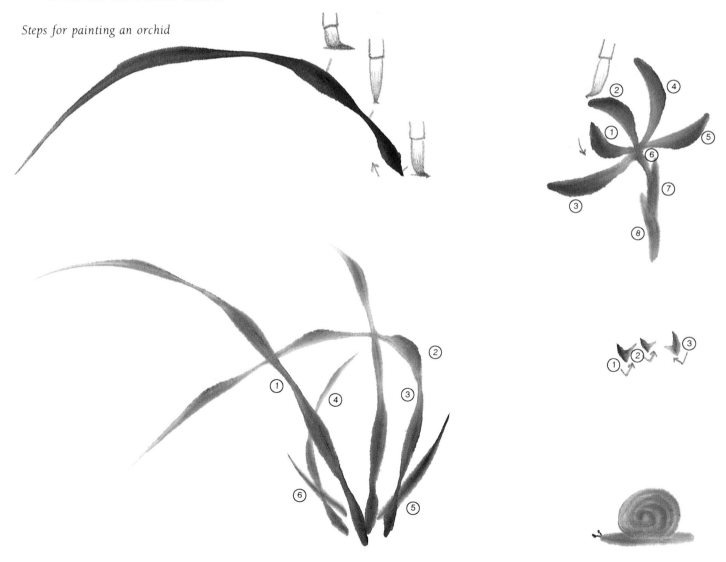

In order to pull the base of the leaves together, paint the fifth and sixth leaves on the outside. Paint from above down to the base. You may add more leaves, but try to avoid creating chaos. Although the leaves are different in length, width, direction, and shadings, together they should create a harmonious whole. Often "less" expresses "more." Expressing many emotions with only a few strokes was the teaching of the old masters.

Flowers

Add a little more dark ink to the tip of the bristles. Holding the handle of the brush upright, paint the petals from the outside to the center. When you alter the pressure you apply to the brush, lines will change to a three-dimensional form.

Flower Stem

Continue working with the brush in an upright position and paint the stem in a gentle shade. Start at the tip and go down to the base, as if the stem were embraced tenderly by flower petals.

Stamen

Fill the tip of the brush with dark ink. The stamen is painted by touching the paper with the tip of the brush and pulling back again, similar to the Chinese character for "heart."

After you have placed little, gentle dots inside, the flowers will look radiant and alive, as if they have opened their hearts, like the love mirrored in the eyes of a woman.

Evaluation

—Did you resist resting your elbow on the table and, instead, let your arm and brush move as one, so that you were able to draw strong, flowing lines?

—Were you able to create sufficient shadings that achieved the necessary three-dimensional effect to allow the flowers to breathe freely in the white space?

—Does the alternating pressure you used when moving the brush across the paper make it look as if a bird were moving its wings?

—Does the stamen, made with little dots, appear as if the flower were showing her heart, as eyes expressing emotions?

Grasshopper

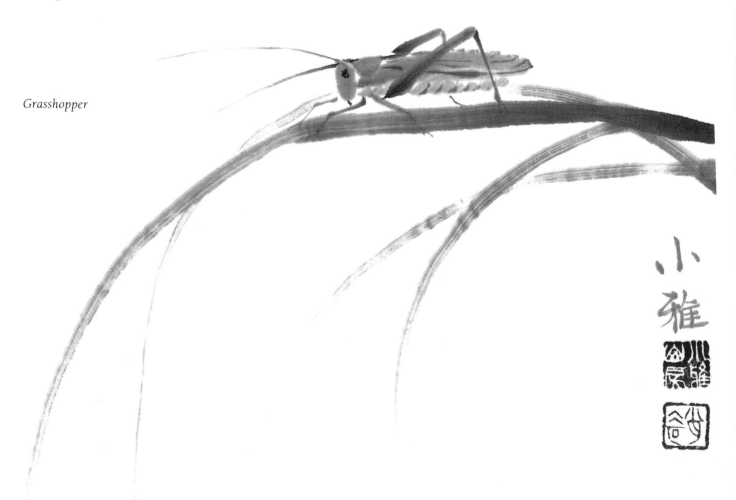

The Third Experiment: Bamboo

A bamboo stick is often compared to life. Each segment of the woody stem has a distinct beginning and an end, a "hello" and a "good-bye," as it were. Growth continues at the mature segment, forming a nodule that is the base for the next woody segment. In Japanese, the word "nodule" is written by using the sign for "moderation." Moderation is essential if life is to flourish. Lack of moderation creates problems. The strong branch of a beautiful bamboo plant could serve as an example of powerful beginnings and beautiful endings.

The Bamboo Branch

The brush is loaded with the three shades of ink and set on the paper with the bristles flattened out. The width of the stem depends on how much of the bristles are in contact with the paper. Push the brush in the direction of the growth of the stem, finishing the segment by applying light pressure to the brush. Continue this technique for the whole stem. The brush will lose much of its moisture as it is pushed upwards. The bristles become "frayed," creating a dry, only slightly colored segment, as if light were shining through. This image can be controlled by increasing or limiting the amount of moisture in the brush and by changing the pressure and the speed with which the brush is guided over the paper.

Nodules

Shape a slightly moist brush into a straight tip on the plate or a rag and dip the tip into dark ink. Hold the handle of the brush upright and let only the tip come in contact

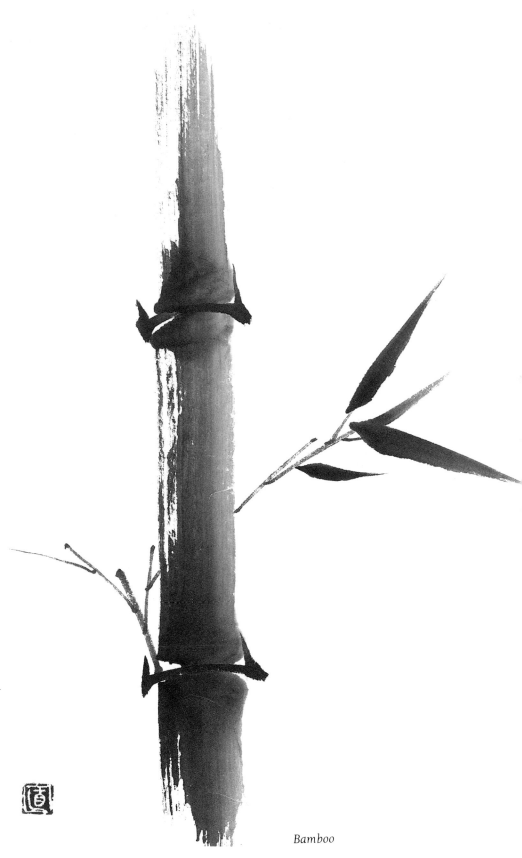

Bamboo

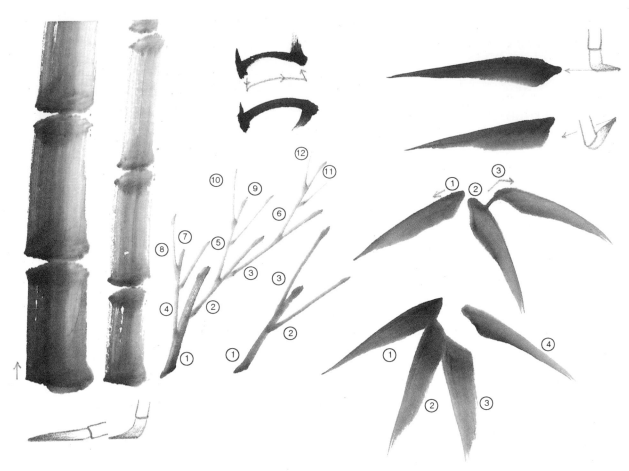

Steps for painting bamboo

with the paper. The tip will look like a hook. Pull sideways and conclude by increasing the pressure, letting the brush move off the paper in an up or down swinging motion, allowing the ink to fade into the white space. This will create a stem with clearly defined nodules.

Branches

Branches growing out from the nodules are painted with a very dry brush, putting less pressure on the paper.

Leaves

Add moisture to the bristles of the brush after it has been loaded with three different shades. Hold the handle upright and quickly pull the brush in one sweeping motion over the paper. Use pressure only as the brush initially touches the paper.

The amount of pressure you apply determines the width of the leaves.

Evaluation

—Are stems, branches, and leaves sufficiently shaded so they express life in its diversity?

—Did you give each stem a distinct beginning, expressing its abundant strength?

—Did you feel the light, the depth, and the quietness of the white space?

—Were you able to give each nodule the appearance of stability, and did you give each one clearly defined accents?

—Are the branches strong enough to carry a heavy load of snow?

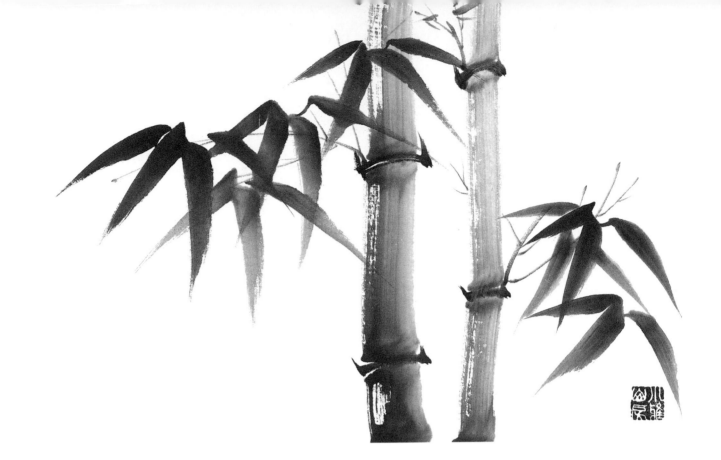

Bamboo Branches

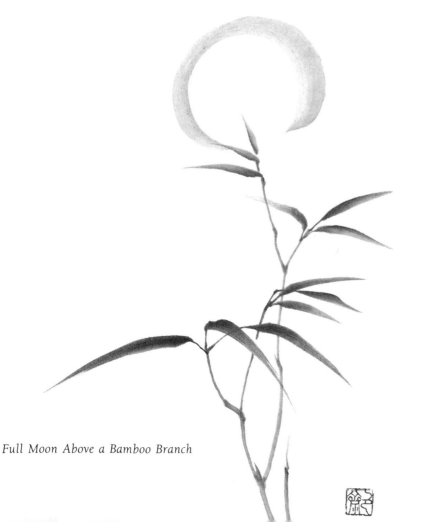

Full Moon Above a Bamboo Branch

The Moon

To paint bamboo leaves, apply the same technique you used in painting the bamboo stems and branches, a process that may be difficult for you. Try to sense the moon in the sky. Expressiveness will not be diminished if you have, in one stroke, painted a perfect circle.

29

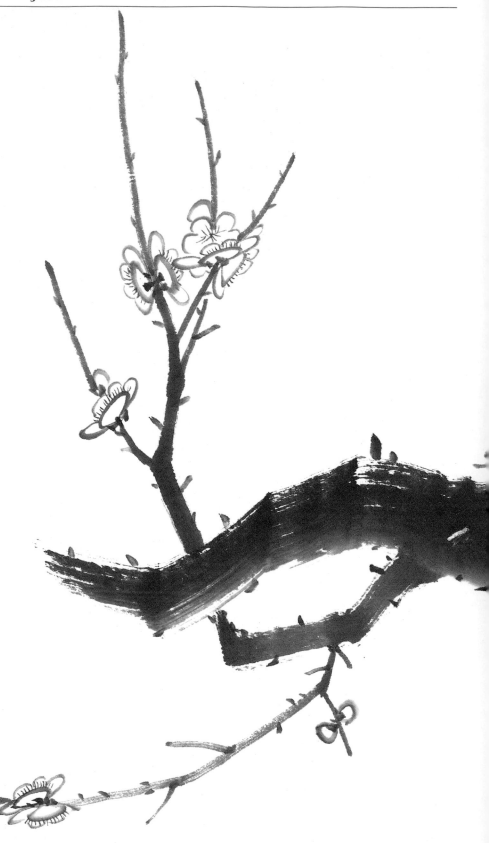

The Fourth Experiment: The Plum-Tree Branch

Plum-tree blossoms, which appear in February, the coldest month in Japan, are, together with pine and bamboo trees, symbols of stability and of good luck for the new year. The new year is also a celebration of welcoming spring. The delicate, fragrant, plum-tree blossoms, breaking forth from old, gnarled branches despite the cold temperatures, are messengers of spring, hope, and the energies of life.

Large Branches

Load the bristles of the brush with ink. Push the brush, held at a more or less steep angle, swiftly as you paint one segment after the other, creating branches that bend in different directions. Feel the tension in the bristles of your brush as you move over the paper. This tension is transferred, making the branches strong and alive. It is helpful if the tip of the brush is bent at an angle as the bristles are pushed forward or sideways. You can also rotate the handle between your fingers as the tip moves along the edge of a branch, allowing the branch to become narrower as it "grows."

Twigs

The tip of the brush, containing less liquid and held upright, is positioned at the branch and pulled swiftly and with even pressure away from it. Do not let the end of a twig blend into the paper. Leave some space for blossoms you might want to paint later.

White plum-tree blossoms

Steps for painting plum-tree branches and blossoms

Blossoms

When painting white buds and petals, load the bristles with the three different shades of ink and hold the brush handle upright. The different shading within a blossom is created by increasing or lessening the pressure on the brush as you paint the individual lines. The shape of individual petals should not be emphasized too strongly.

When painting pink-colored blossoms, the brush is filled with three shades of very light ink. Paint the individual petals with one dab of the brush for each one. This creates differently shaped blossoms, all pointing in different directions.

Red plum-tree blossoms

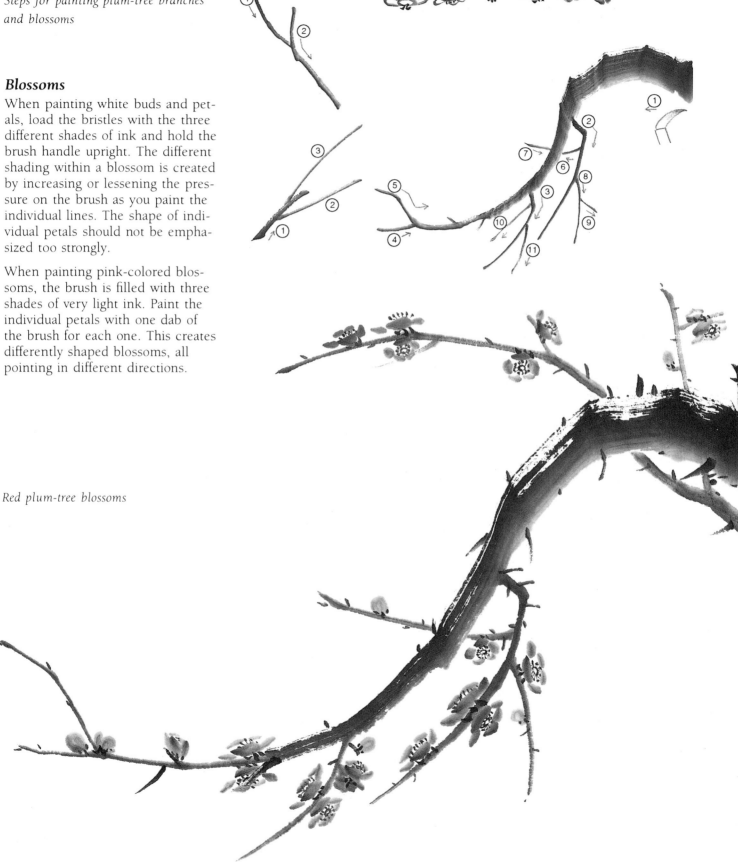

Willow with catkin

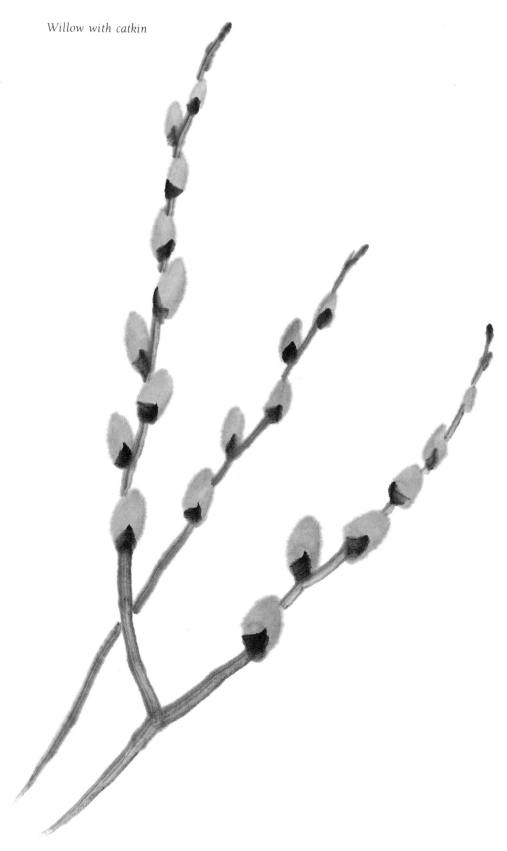

Sepals

Sepals are the connections between blossoms and twigs. Load the brush with the darkest ink. The bristles should be almost dry. As soon as the tip has touched the paper, pull the brush away with a swift motion, the same way you did when painting the stamen of an orchid.

Stamen

Give the tip of the brush as fine a point as you can, and load the bristles with as little moisture as possible. Although the tip is fine, each line must be painted with a resolute stroke. Using dark ink, add little dots above or below the line.

Evaluation

—Did the energy of life flow into the twigs and branches, so they radiate strength and vitality? Painting over a previously painted surface robs it of this flow.
—Establishing contrast between a gentle flower petal and a rough branch or twig creates a beautiful blossom. Can you detect in the branch the many years of its growth, a sign of its life?
—Did the white space gain in depth because of the lively crisscrossing of twigs and branches?

Additional Practice

Willow

At first sight, what seems to be a rather difficult task—painting the catkins—has been done successfully even by beginners. With a brush that is loaded with somewhat more water and with an ink that is not too dark, paint the catkins by dabbing the brush on the paper. Use a drier brush and darker ink for the sepal and paint the twigs as we discussed before.

Pine Tree

Branches of pine trees have a completely different character than those of plum trees. They provide good practice for painting branches. These branches are painted with the brush held at an angle. Twigs are painted the same way as plum-tree twigs, from the larger, rougher branches to the smaller ones. Pine needles are painted with a brush that is almost dry, held almost upright. Conclude by painting the bark with an almost dry brush and dark ink. To create a solid line, push the brush forward.

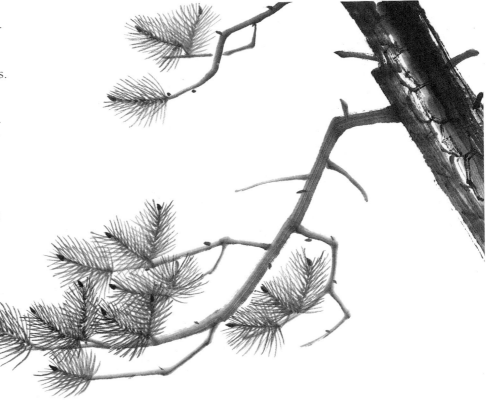

Pine-tree branch

Steps for painting a pine-tree branch

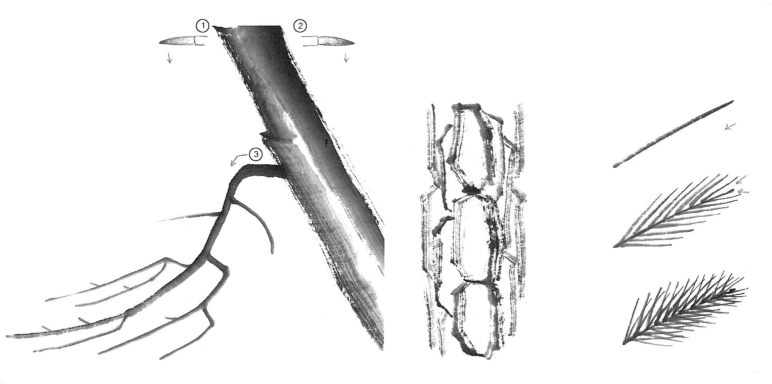

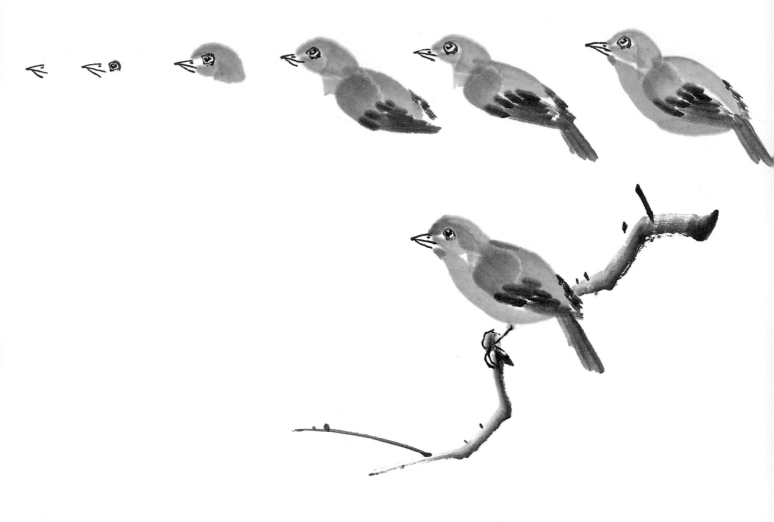

Bird on a Branch

When painting a bird, we usually start with the beak, first with the upper half and then the lower. The position of the beak determines the position of the bird's head and body. Paint the beak and the eyes with a stiff, dry brush containing dark ink. The way the eyes are painted determines the expression. Use the darkest shade for the pupils. Continue by painting the head, then the body, followed by the tail feathers. For the chest and belly, use a lighter shade. Use a darker shade for the wings and the tail. Paint these before the previously painted, lighter parts have begun to dry. Conclude by painting the feet and claws, using a dry brush filled with dark ink.

It is helpful to paint the whole body of the bird in a lighter shade and then overlay the wings and the tail with darker ink. This prevents unevenness that can otherwise disturb the finished painting. Only after the whole bird is finished do you paint the branch on which it is sitting.

Steps for painting a bird

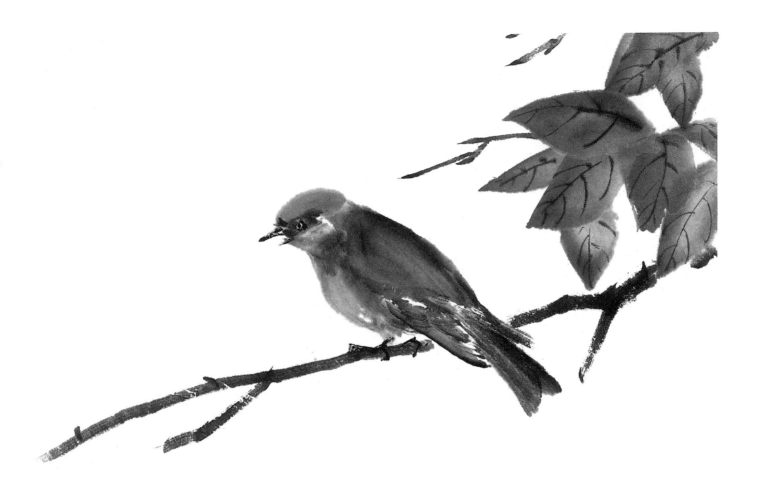

Bird on a branch

Bird and Flower Painting

There are two types of ink paintings. The first is landscape painting. In Japan, this is known as mountain and water painting. The other is referred to as bird and flower painting.

The latter consists of paintings of flowers, trees, and animals. This type of painting emphasizes contrasts between stillness and motion and between softness and strength. Stillness is represented by trees and flowers; motion, by animals, such as birds. Contrasts make a picture come alive. Painters, in admiration and love of nature, reach for their brushes, go outside, and use these motifs in their paintings to capture their emotions.

A painting of a bird does not always reveal whether the painter is secretly longing for freedom, or if he wants to remain in a warm nest. However, sometimes one of my students may subconsciously give expression to a longing by the expressive way he paints a bird. Then I have to smile. In general, human beings seem much happier where they are than they think they are. Most really don't want to leave their nests.

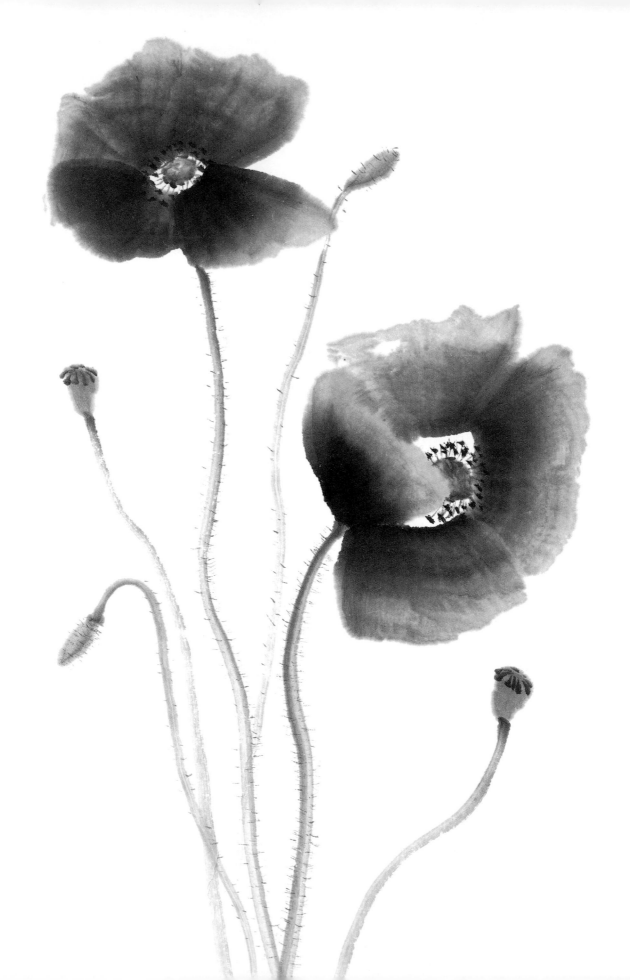

Exercises for Creating Space

With the Brush Held at an Angle, Almost Flat on the Paper

Poppy

I was fascinated as the delicate petals of the poppy came alive through the brilliant color of the ink. It seemed as if butterflies were tumbling about. At the same time, I thought of the Acropolis, an infinitely deep, azure blue sky, and the intensely brilliant colors of poppies in bloom!

Flower Petals

Load your brush with the three different shades of ink, pushing it over the paper in the order given in the drawings below.

The Center of the Flower

With the tip of the brush, make little dots in the shape of a triangle. For the pollen, use the darkest ink possible.

Stamen

The stamen is painted by dabbing the tip of the brush with slight pressure on the paper, decreasing the pressure as the brush is pulled down and off the paper. The stamen is painted with very dark ink.

Stem

First, establish the width of the stem by using the appropriate pressure. When the right width is achieved, pull the brush downwards.

Hair

We use a special technique for painting hair. Begin by pushing just the tip of the upright brush on the ink plate, then moving it back and forth in the ink. The bristles will become frayed and take up very little ink. Hold the frayed bristles between your thumb and index finger so as to form a tiny "brush" with short "bristles." Use these bristles to add hair to the stem, pulling the bristles away from the stem to the outside.

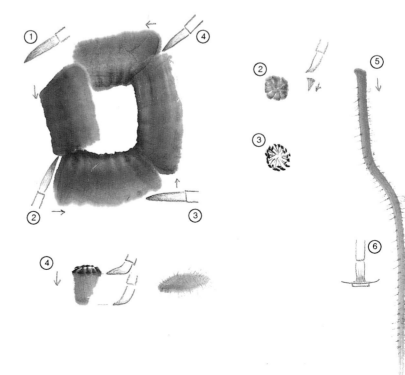

Steps for painting a poppy

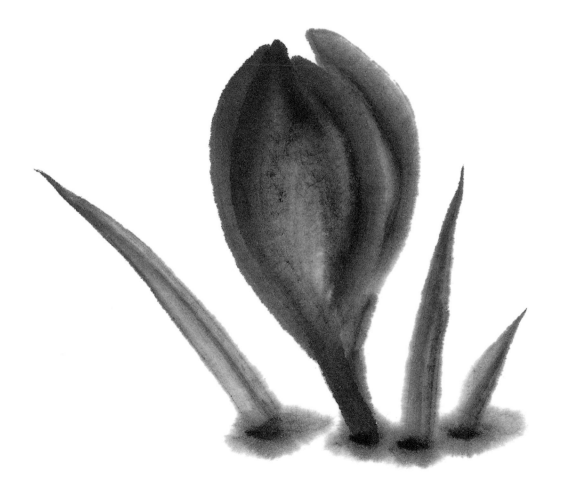

Rotating the Handle of the Brush

Crocus

A sight to behold! A yellow crocus on a green meadow, a magnificent lilac-colored crocus still surrounded by snow. Painting small dabs of ink on the "snow" allows us to sense the warmth of the earth and the vitality of the crocus.

In practical terms, painting a crocus is one way of practicing rotating a brush around its own axis. This means moving the brush itself as it is moved across the paper. In one swift motion, you are able to create the shape you want. Even though this is somewhat cumbersome in the beginning, you can immediately see the effect of the shape you have created.

Flower Bud

Start with the petal in the center. Guide the brush on an angle with the tip in an upward motion. Rotate the brush to the left and outside. Pull the brush downwards as you decrease the pressure. You just painted the left half of a petal! Continue with the right half in the same fashion. The handle of the brush moves to the right. Add both the outer leaves, proceeding as you did with the petal in the center.

Stem

Set the tip of the brush underneath the flower and pull downwards.

Leaves

Start at the tip of the leaves, using the tip of the brush. Pull the brush down as you increase the pressure, widening the leaves.

The Hole in the Snow

Add very watered-down ink around the place where the leaves "grow" out of the ground.

Steps for painting a crocus

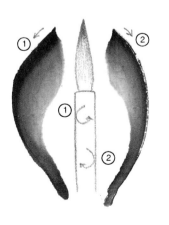

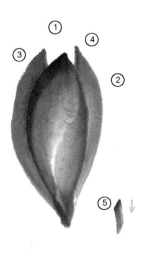

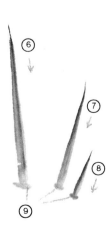

Crocus in the Snow

Stem *Leaves*

Tulip

Every time spring rolls around, I am inspired to paint tulips. The lush green leaves are literally bursting with energy. My obsession with creating dynamic movement in one stroke often means the leaves I paint appear to be stiff and rigid. And one would think that tulips are flowers of such simplicity and liveliness!

The Flower

Hold the brush, loaded with the three shades of ink, on the paper at an angle and rotate the handle towards the outside. Begin the second stroke at the tip, somewhat offset, and rotate the brush in the op-posite direction. Paint the third leaf, in a lighter shade, behind and between the first two.

Stem

With the handle held upright, pull the brush from the base of the flower down to the edge of the paper.

Leaves

Paint the leaves in one stroke from the top down, using first the tip of the brush. At the place where the leaves increase in width, rotate the brush sideways until it rests flat on the paper. Use the whole length of the bristles.

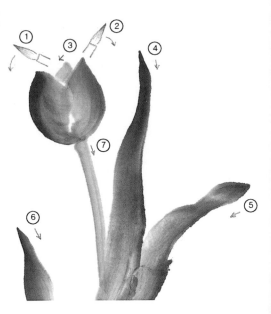

Steps for painting a tulip

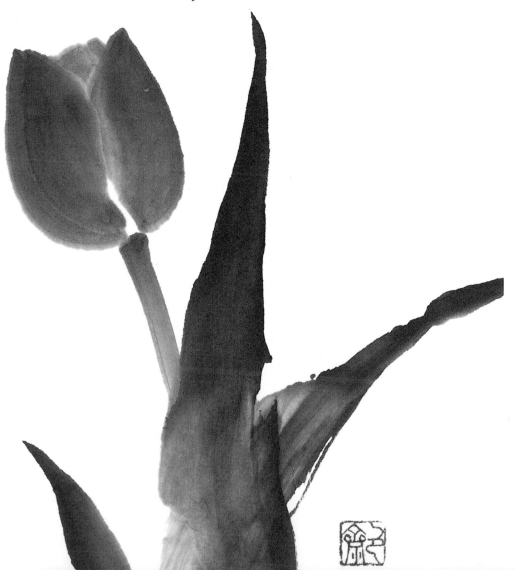

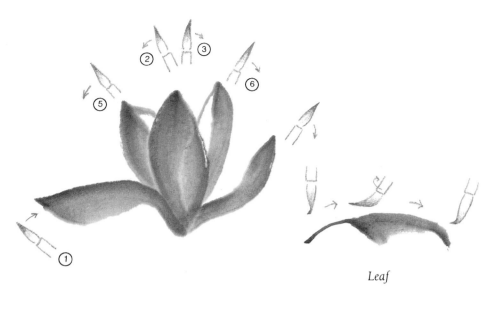

Steps for painting a magnolia blossom

Leaf

Magnolia

A magnolia tree, with blossoms that look like candles, is simply one of the most beautiful sights in all of nature. Looking at this tree in bloom always reminds me of the expression on my mother's face when she talked to us about the moment when our magnolia tree began to burst into bloom.

The Flower

Begin with the outermost left petal. Pull the brush from the outside to the inside while rotating it to the left. The petal in the center is painted in two stages. The brush rotates and is pulled from the outside to the inside. Add the right petal. Following the same sequence, add

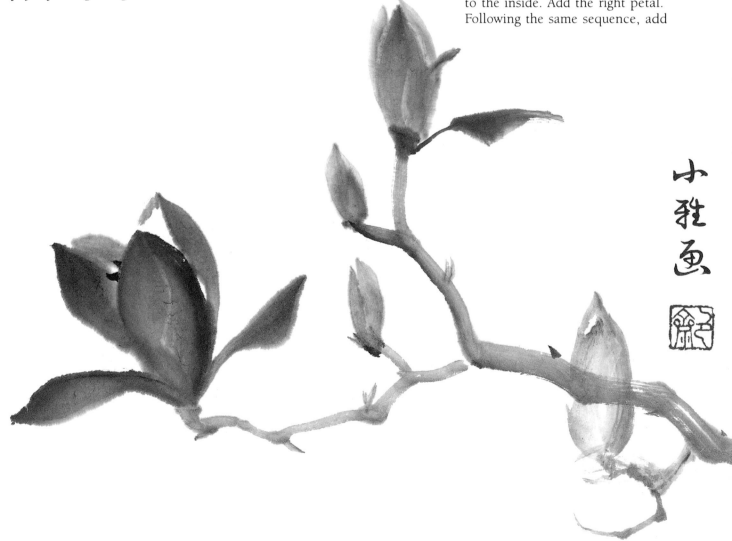

the petals in the back, behind the other two. Conclude by dabbing in the stamen with dark ink.

Buds
Paint the buds the same way as we have discussed for the large flowers, using two or three strokes.

Sepals
Add sepals at the base of the flower or at the bud. Make sure that the shade of the sepals stands in contrast to that of the petals of the flower.

Twigs
In order to give life to the stems and twigs, take the moisture out of the brush and fill the tip of the brush with dark ink only. Draw the stem from the base of the flower towards the twig.

Leaves
When painting the large leaves, start at the point where they emerge from the twigs and move up towards the tips of the leaves. Paint the small leaves with the tip of the brush.

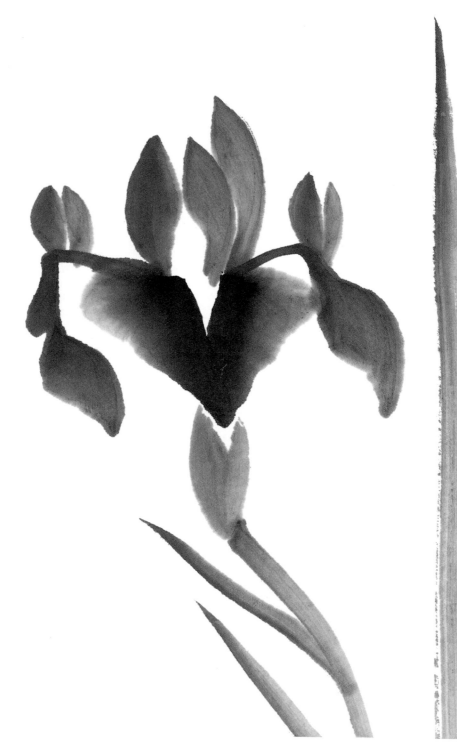

Large Areas Painted in Two Strokes

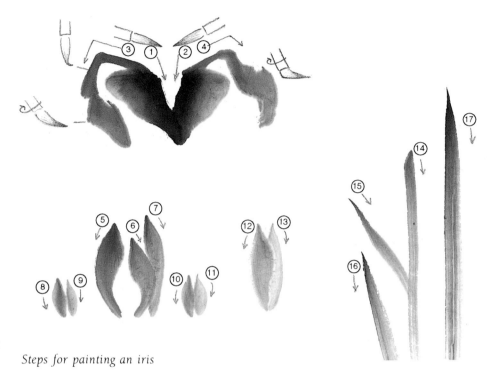

Steps for painting an iris

Iris

We distinguish between irises that are short lived, which have distinctly shaped leaves, and the other irises, with their more gently shaped leaves. Every year on the fifth of May, the Feast of the Boy, the latter type of iris, together with a picture of the armor of a samurai, is used for decorating. Its upright shape and strong growth best symbolize the ideal of the samurai.

Flower

Start with the petal that extends down from the center. In order to make the seam, created by two overlapping lines, less obvious, load the brush with the three different shades of the ink and follow this seam. Use the tip of the brush, allowing the darker ink to run to the inside. If a dark area overlaps another dark area, the seam will hardly be noticeable. This is the method to use when covering a large, uniform area. The petals extending to the sides are painted by altering the pressure and by rotating the handle of the brush. The three small petals and those that grow beside each of the lateral petals are also painted by rotating the handle of the brush.

Sepals

Sepals, too, are painted in two stages. Each time, pull the brush sideways while rotating the handle. If you have used light ink, the line between the two sepals will be visible. In this case, that is the effect you want to achieve because it shows the proper, curling shape of the sepals.

Stem

Hold the brush upright and, beginning at the base of the flower, pull down to the edge of the paper.

Leaves

Holding the brush upright and, with continuously increasing pressure, start at the tip of the leaves and move the brush downwards. Before painting the leaves that stand erect, reload the brush with a little bit of dark ink and, as you hold your breath, pull down towards you. Your breath should stay in your belly.

When painted in this way, the tips of the leaves become dark, giving the impression that the leaves are reaching, growing, towards the sky. The process began in stillness, but the slightly curved tips speak of bursting energy.

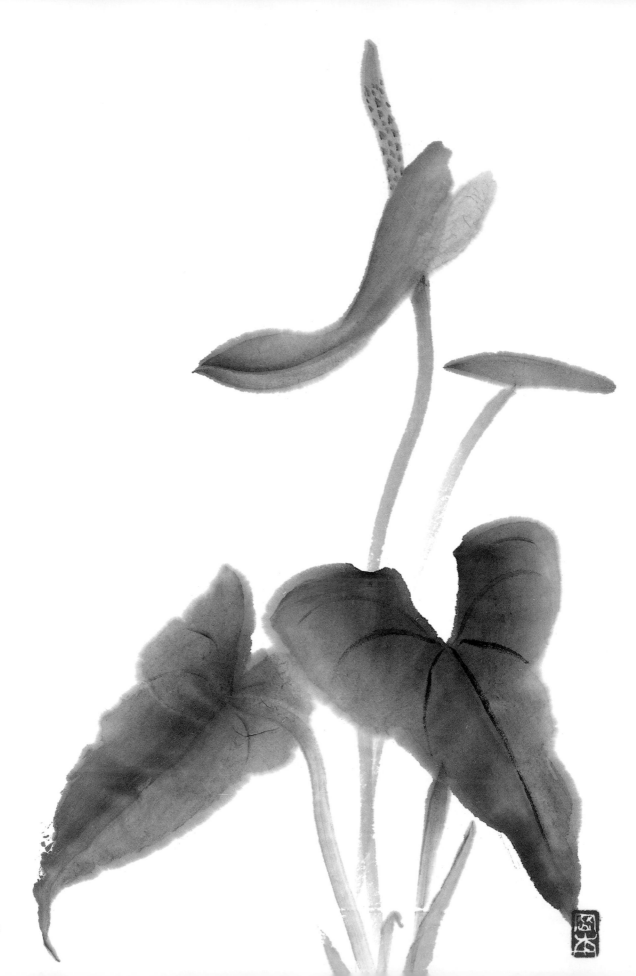

44

Anthurium

Whenever I look at an anthurium, I think of a kite soaring gracefully in the sky, and I, too, want to fly.

Flower

To paint the flower, load your brush only slightly with ink (in three shades, of course). Hold your brush at an angle and push the bristles down until one-third of the length of the bristles is in contact with the paper. Without hesitation, pull the brush, while rotating the handle, swiftly upwards to the right. With a second stroke, and in a lighter shade, paint the underside.

Leaves

Load your brush with ink that is relatively dark, but maintain three shades. Paint each leaf in two stages. With each stroke, the tip of the brush moves along the center at an angle from the top to the base. When the ink is almost dry, paint in the veins with dark ink.

Stem

Paint the stems in a lighter shade and move your brush from the base of the flower down to the edge of the paper.

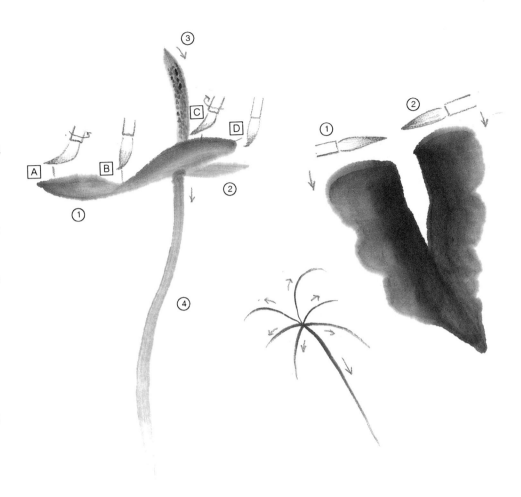

Steps for painting an anthurium

Lost Forever

Time and again the question arises, "Is it possible to correct a shape that has already been painted on paper?" My answer: "No law says that you are not allowed to do it." However, you will quickly learn that when you, for instance, add another line to correct the one already on the paper, something irretrievable has been lost, even if you have improved on the original form and made it more beautiful or more realistic.

This concept also applies to Japanese tea ceremonies, where the central meaning lies in the uniqueness of the moment. In order for this unique encounter to be fully experienced, the shape and course of each individual motion or movement is determined beforehand. In similar fashion, the process of painting is reduced to its essential minimum, and a painter practices the movement of the brush on paper until the form created is as natural as possible. In contrast to the concept as practiced in Western art, where the end product is more im-portant than each individual line, in *sumi-e* every brush stroke must be right because correction is not possible. Each individual line tells the story of the process. Each line is connected to the next and to the whole; each line is important as it appears on the paper; each line is a mirror of the attention, energy, and the soul of the painter. What is lost in trying to make a line more beautiful is the "tension of the silence," a place of purity, where the energy of silence is present. That is what fascinates and moves me.

Rough Outline with One Stroke

Promontory

A student of mine, returning from a vacation on the Mediterranean coast in southern France, told me that he brought back with him the image for the painting he was doing in my class. He literally experienced the Mediterranean coast as reality while he was painting. I was overjoyed!

I am sure that at some time, somewhere, you have seen a promontory similar to the one on this page. Try to make a rough outline of it with one stroke. Everything that isn't essential is left out. The essentials are given form and shape. Add only those details that are important to you.

Load the brush sparingly with the three shades of ink. Determine the line at the horizon. The brush lies flat and is pulled horizontally over the paper. The tip of the brush becomes the tip of the promontory.

If the promontory features something like a mountain range, pull

Fishing Boat

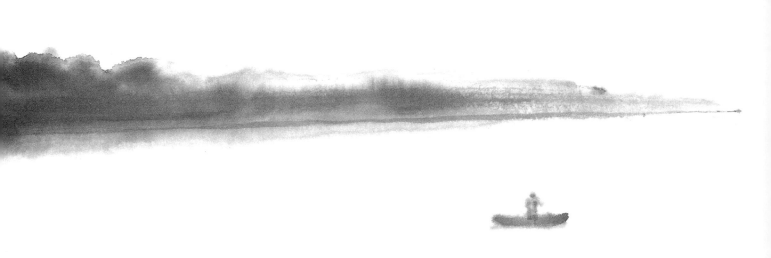

the brush somewhat more to the right, rotating it so that the tip of the brush creates the edge of the mountain. If you want to "plant" trees, hold the handle of the brush at an upward angle, pulling it horizontally with a vibrating motion. If you want to create a greater space or produce movement in an otherwise static painting, add a bird and make it seem as if it is flying to a faraway place.

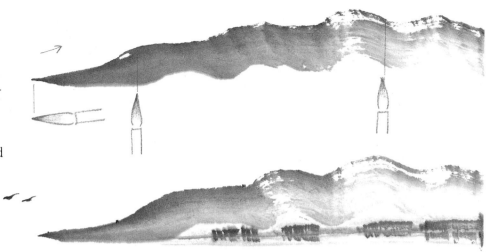

Promontory

Steps for painting a promontory

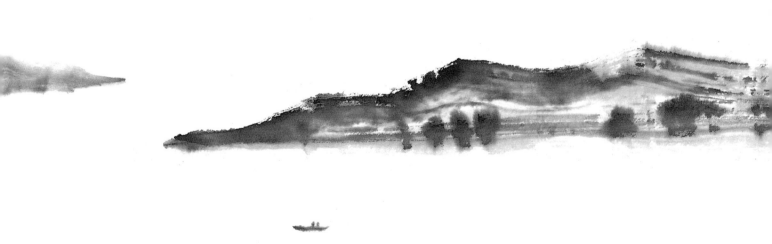

PAINTING OBJECTS

Still Life in Ink Paintings

As an art form, still life expresses the essence of ink painting particularly well. While in Japanese the phrase "still life" is written in the Chinese signs for "quietness" and "object," it is understood that this art form doesn't represent an arrangement of "dead" objects, as in Western art; rather, a still life is an arrangement that tries to convey the deeper nature that exists within. A still life ink painting has three-dimensional qualities, but it doesn't make use of light and shadow, because these are changeable and temporary. It also does not use horizontal images or objects such as a tabletop for placement, and, most of all, it does not use a background.

In a still life, the space is the whole cosmos. You are not trying to conquer it; rather, you create it by losing yourself in that space. It is a space where everyday life becomes one with eternity. The cosmos is

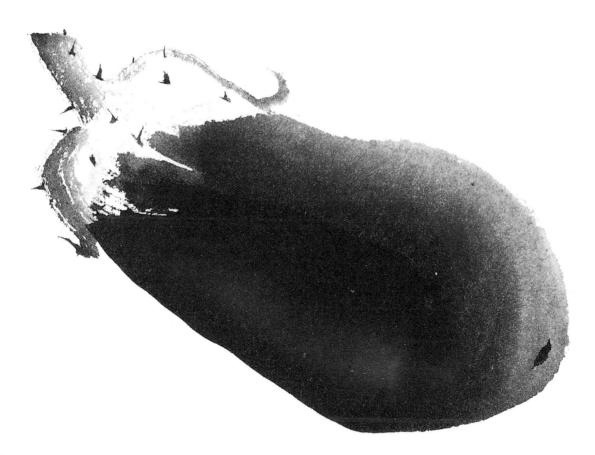

Eggplant

all-inclusive but not limited; it is nature.

After I saw the still life paintings of the Italian painter and graphic artist Morandi (1890–1964), and after I immersed myself in ink painting, it became clear to me what I had not noticed before: his is the Western, artificially enclosed space, created by using light, shadow, and background.

In *sumi-e,* a still life is not an attempt to describe an object; rather, it gives reality to an object, representing your subjective, emotional perception. In contrast to Western paintings, where a painter tries to capture reality by adding details, an ink painting only presents the essentials, with as few brush strokes as possible, bringing the painting to life by finding its energy.

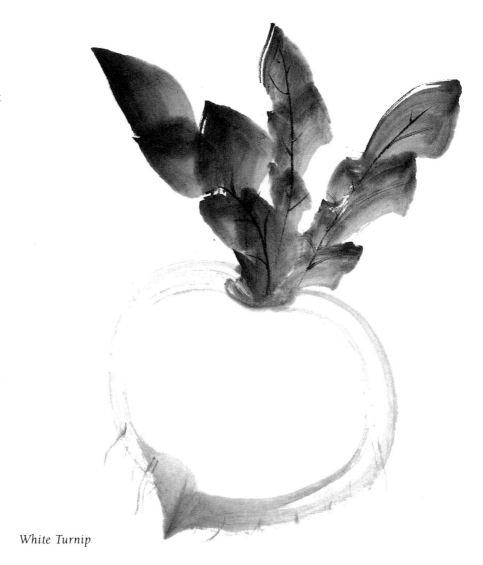

White Turnip

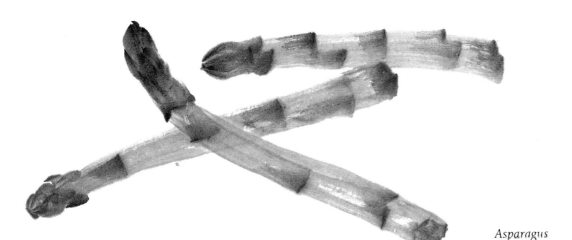

Asparagus

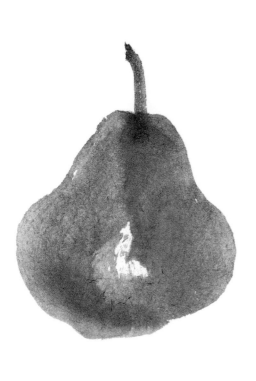

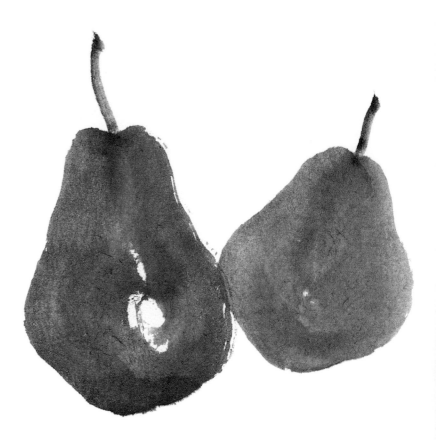

"Guest, Host, and Servant"

About Compositions: Harmony and Contrasts

In ink paintings, composition determines the harmonious relationship and distinction that exists between emptiness and fullness and between a star and the supporting actor.

The area in which you work is divided into the emptiness, where there is nothing, and the space that is filled, where you paint. In order to create contrasts, the painted space must be sparse and dense, heavy and light, dark and bright, and contain big and small things and distant and close objects.

Those parts that are dense, heavy, dark, large, and close represent the fullness; those that are sparse, bright, light, small, and far away represent emptiness. While emptiness and fullness create contrast, they must complement each other and exist in harmony.

You must make clear which object is primary and which is secondary. Paint the primary object first and then the secondary. If a composition consists of three objects, paint them in the order of "guest, host, and servant." The relationship between objects gives a painting life and balance.

Pears

Start with the pear in the middle. Load your brush with three shades of ink. Hold the handle at an angle, painting the left half of the pear first. Make sure that the tip of the brush gives shape to the outer contour of the fruit. Rotating the handle of the brush will give the lower half its width. The width of the pear is determined by the length of the bristles. Continue by painting the right half of the fruit, again, starting at the top and moving the brush downwards. The second pear, which is playing the supporting role, is lighter, but the ink also contains all three shades. It is okay for the left side to overlap the first because the

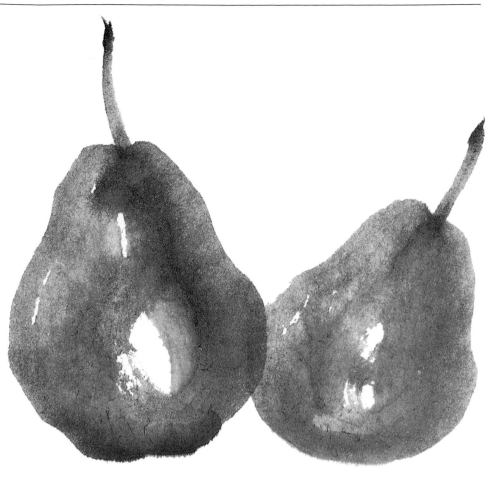

darker ink is dominant, making the
lighter area appear to be behind it.

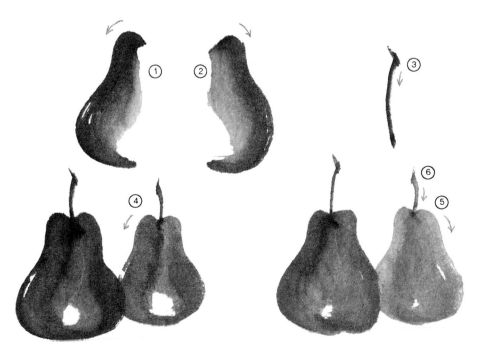

Steps for painting a pear

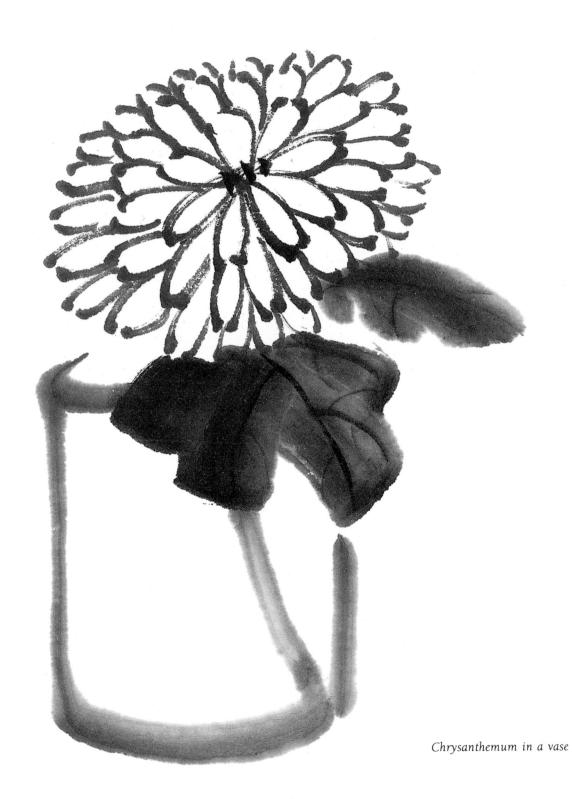

Chrysanthemum in a vase

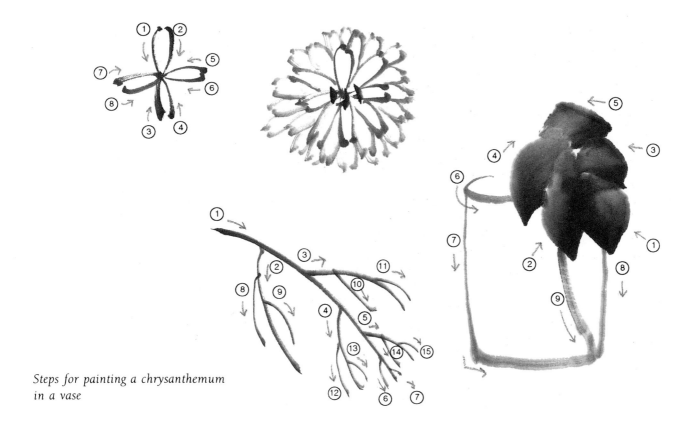

Steps for painting a chrysanthemum in a vase

Chrysanthemum

Along with the bamboo, orchid, and plum tree, the chrysanthemum is one of the "four aristocrats," described in the *Mustard-Seed Garden,* a Chinese textbook from the seventeenth century. Chrysanthemums are symbols of autumn. They are also symbols of loyalty and devotion.

Begin by painting the central petals first, working your way from there to the outside. Load the brush with three shades of light ink. Draw the outline in two separate brush strokes, holding the handle upright and pulling the brush from the outside to the inside. However, make sure that the petals are not all the same width. As you did when painting the bamboo nodules, set the tip on the paper with a little bit of pressure and pull the brush to the center of the flower. In this way, each petal tip is somewhat prominent and three-dimensional. For the leaves, use darker ink. Pull each individual brush stroke from the outside to the center, creating each whole leaf in one stroke. Work from the tip to the base.

The vase is painted in swift brush strokes with the handle held upright, using three light shades. The contrast between the white surface and the ink makes the vase appear to be made of glass.

Finally, with dark ink, add veins to the leaves and to the center of the blossom.

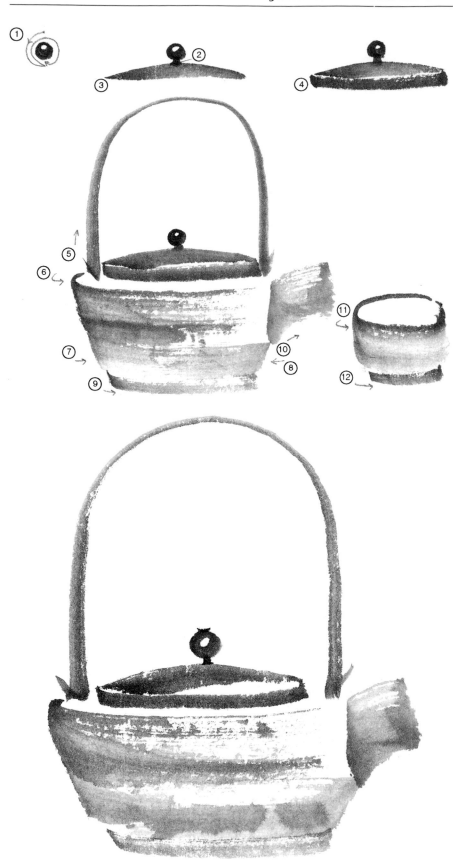

Steps for painting a teapot and a bowl

Teapot

The knob on the lid is drawn with the tip of the brush. Rotate the handle of the brush, starting at the top. Move to the left and down and immediately go back again to the starting point, moving the brush to the right and downwards. To paint the lid, hold the brush horizontally, pulling it to the right while rotating the handle of the brush to the outside. The base of the lid is painted with the brush in an upright position. Do likewise when painting the handle. Hold the handle of the brush upright. For the belly of the pot, hold the brush at an angle. For the bottom, hold the brush upright again. To paint the mouth of the pot, start at the belly and move the brush to the left and out. For the bowl, load the brush with three shades of ink and hold it at an angle. Start with the tip of the brush at the left side and, with a rotating motion, swiftly paint a broad area, ending with the brush in an upright position, drawing the bottom of the bowl.

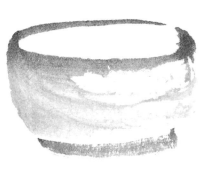

Mushroom

To paint the underside of the mushroom, have your brush loaded with three shades of ink. Begin by setting the tip of your brush on the paper. Pull the brush slowly to the right while applying pressure and rotating the handle. Conclude this stroke with the tip of the brush. The upper portion of the mushroom is painted in the same way. The lamellae on the underside of the mushroom are painted by loading the brush with very light ink and, starting at the base of the stem, pulling the tip of the brush quickly to the outside.

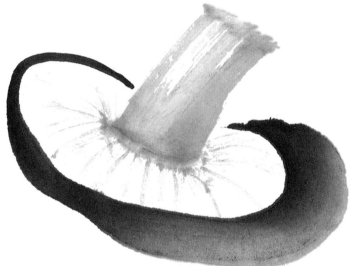

Steps for painting a mushroom

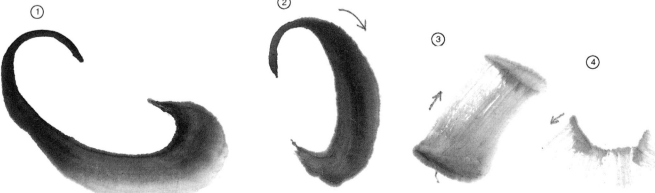

Landscapes in Ink Paintings

Landscapes were painted in northern China in stylized form as early as the tenth and eleventh centuries. Distinct lines dominate these paintings.

Classical landscape paintings have always occupied a very special place among ink paintings. In Japan, they are called *Sansui-ga* (mountain and water pictures). However, *Sansui* paintings are distinctly different from today's landscape paintings. In ancient times, it was thought that mountains and rivers were the places where the gods resided. One believed in the great power of nature. *Sansui* paintings are found on the walls of temples side by side with Buddhist paintings. They were symbols of ideas and a means to honor nature. For that reason, it was important to create mountains, rocks, and trees as lifelike as possible. This was accomplished with very strong brush strokes and, in contrast to Western paintings, by avoiding a specific point of focus. Visual forms seemed to grow from within the lines, creating a painting of the universe.

A *Sansui* painting did not attempt to be a representation of the manifold objects present in nature or to convey a personal impression of a particular part of nature from a particular vantage point; instead, the painter used mountains and water in an attempt to reconstruct the universe. As this type of art developed over time, it became more and more stylized.

You are not required to adopt this type of stylized "line" painting if you prefer a more spatial representation. By this I mean, ink paintings in which less defined outlines of objects are used. Paintings that use more diffuse contours developed in the milder and more humid climate in the southern parts of China. (An example of this style is the painting on page 64.) Nevertheless, by getting to know this stylized type of painting, you will learn how to create spatial effects without the use of light and shadow.

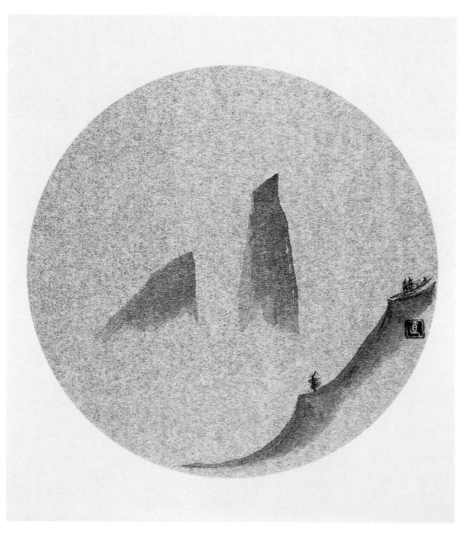

"Tall Mountain Top, Not Meant to Be Climbed"

A Study of Trees

Trunk

If you want to create a trunk with a flat look, start where the thickest branch begins and pull the brush down to the base. When outlining a trunk, you may move your brush in any direction you like. Try to draw lines without hesitation, in one brush stroke. Do not use small strokes, as you would in a pen-and-ink drawing. Try to give the trunk an irregular width as the brush moves over the paper.

Twigs and Branches

Paint the branches first, then the twigs. Generally speaking, twigs and branches on the left side of a tree are painted from the top to the bottom and from left to right. The twigs and branches on the right side of the tree are painted from the bottom up and from right to left.

Leaves

Leaves can be painted two different ways. The orthodox method involves painting only the outline. In the other way, which developed later, the ink is dabbed on the paper with the tip of the brush without clear outline. Leaves with serrated edges are dabbed on the paper with an old brush that has short bristles.

Crown

Before you paint the crown of the tree, paint the trunk, the twigs, and the branches. In order to create an expansive view, start dabbing from the outside to the center of the crown, so that the leaves are more dense on top and the outside than those that are closer to the trunk and the inside. Darkness versus light and wet surfaces versus dry spaces, when properly distributed, will give dynamic energy to the tree. When painting a group of trees, always start with the one that is closest to you.

The basic shapes of trees

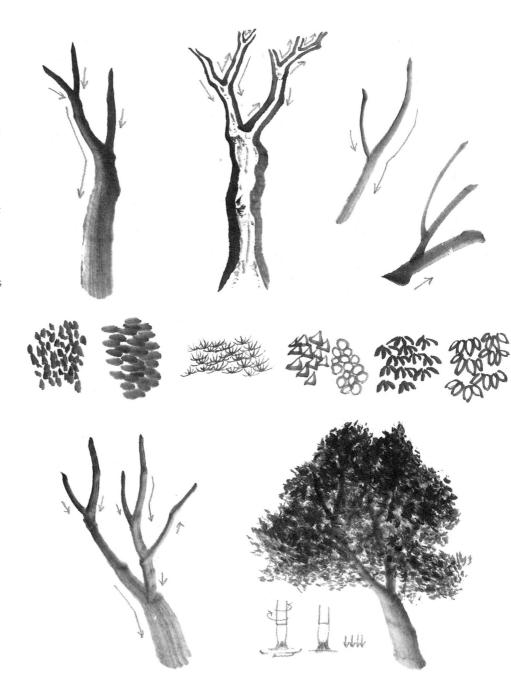

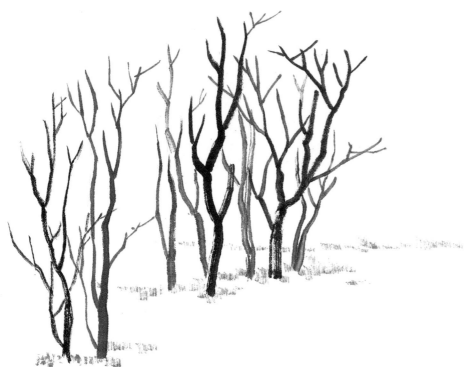

Trees in the Field

This is an exercise in painting trees. If you want to paint a group of trees, make sure that you vary the lines of the branches and twigs. There are those that are dry and old; others are alive and young. Some are thick and dark; others are thin and lighter. Make sure that the skeletons of the trees, the trunk, twigs, and branches, have an expansive character. Three-dimensional effects are achieved and a painting comes alive when strong lines and broader brush strokes are alternated.

Field in Winter

Field in Summer

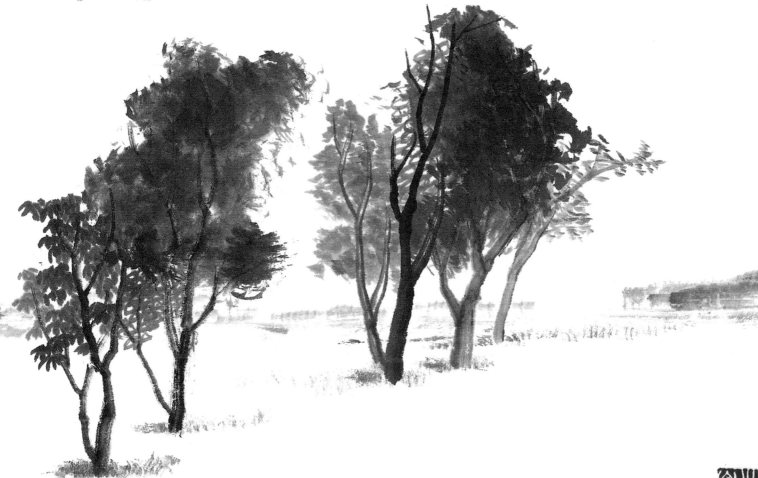

River in Spring

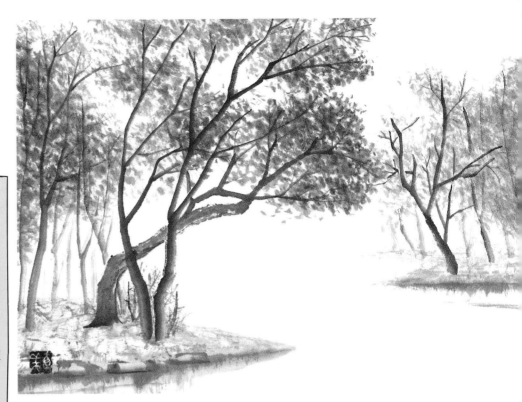

Reality and Imagination

It was a magical experience. Suddenly, I was surrounded by the soft light of spring, sensing the cool air on my cheeks. It was as if I were walking along a river. Memories from the past seemed to come alive. I was adding little dabs of ink to a branch, indicating the sprouting of new leaf buds on the bare branches. I felt surrounded by beautiful light. I was walking along that river again! Ink on white paper, in a wet or dry state, can evoke images of light and of different shades of color, creating a wonderful atmosphere. The expressions created in ink paintings are immediate and true. Black-and-white photos can never hope to achieve the same effects.

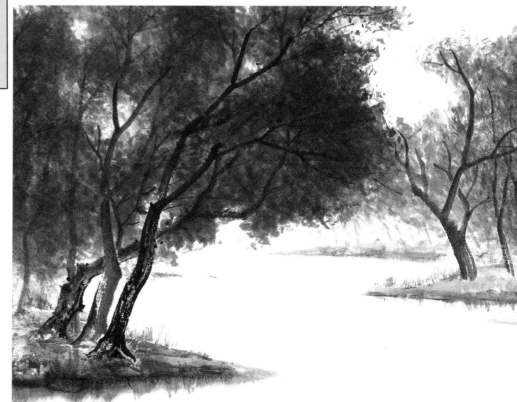

River in Summer

Weeping Willow

When painting the trunk of a weeping willow, pull your brush from the top down to the base of the trunk. I do not recommend starting at the base of the trunk and painting upwards. Initially, by holding the handle of the brush at an angle, it looks as if it might work; but as you continue to move upwards, rotating the handle and pushing the brush, the bristles begin to spread apart, making it difficult to decrease the width of the trunk, as it does naturally when it gains in height. Start the trailing branches at the trunk, where they are thicker, and end at their tip, where they become increasingly thinner.

A lake and its shore,
tranquil and transparent,
water's reflection of fall.
(Buson)

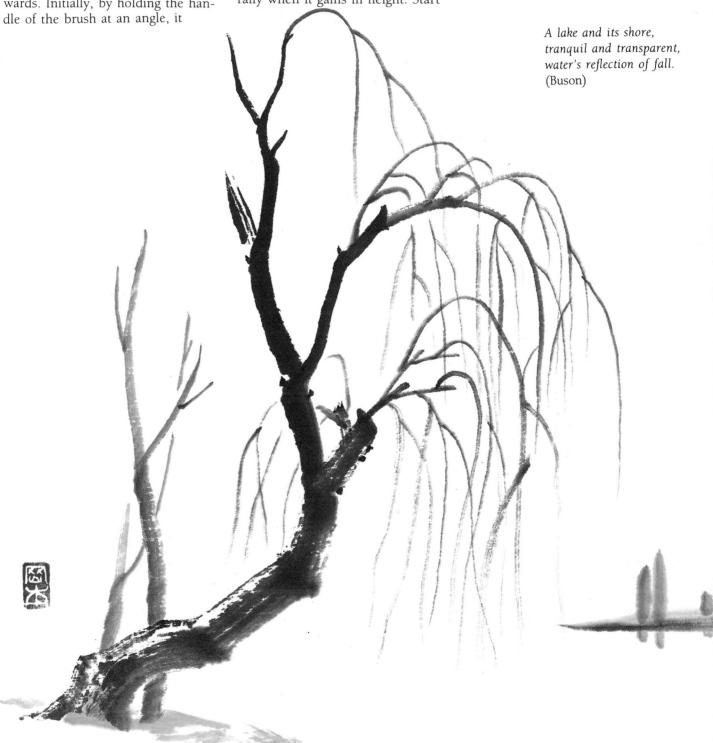

Mount Fuji—The Holy Mountain (with pine trees)

This very popular motif has been painted by artists over and over again. It is almost the symbol of Japan. Singularly beautiful, Mount Fuji is the highest mountain in Japan, rising cone-shaped from a wide base with elegant proportions. This mountain reaches a height of almost 12,500 feet (3800 m), and it constantly changes its appearance, depending on the weather, the light at a given time of day, and the season of the year. Today, Mount Fuji is a symbol of beauty and of Japanese aesthetics.

Together with the pine tree, the symbol of long life, Mount Fuji is also the symbol for luck. During the month of January, a picture of this mountain, including the pine tree, decorates the *Tokonoma* alcove in every Japanese house. Looking at beautiful Mount Fuji makes my heart skip a beat.

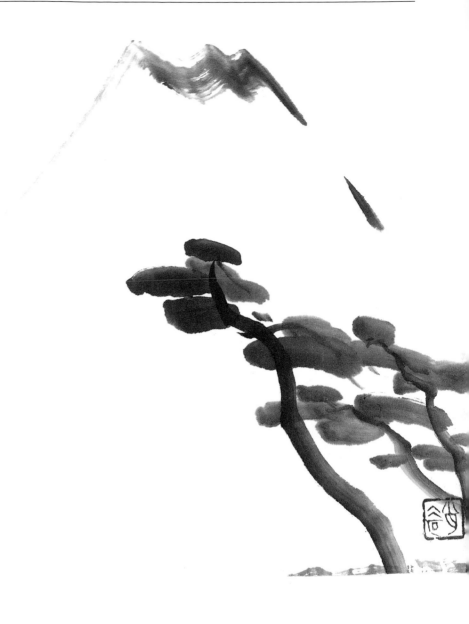

The Stages of Painting Mount Fuji

Set the tip of the brush on the paper and begin by pushing it at an angle from right to left in an upward motion. Without stopping, continue in an up-and-down movement to the end of the left edge of the summit. From that point on, pull the tip of the brush down and out over the left edge of the paper. The painted line disappears slowly into the white space.

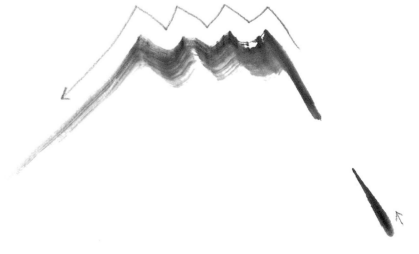

The Study of Rocks

In addition to depicting objects in a naturalistic style, *sumi-e* also shows objects abstractly. However, abstract objects never appear to be dead, inorganic, or geometric; rather, their essence is life and energy.

For instance, a rock is given life through the dynamic use of a brush stroke. However, make sure that the painting shows the three-dimensional, hard, solid, and heavy character of the rock. This is achieved by varying the amount of pressure used while painting and by using irregular shapes, different shadings, and different brush movements. In order for the stone to come alive, make sure the brush stroke has vitality. For that, of course, your hand movement must have certainty, because with every hesitation, ink builds up in the tip and flows out suddenly when you continue, making a line appear to be weak. This means you must know the whole outline of your rock before you even reach for the brush.

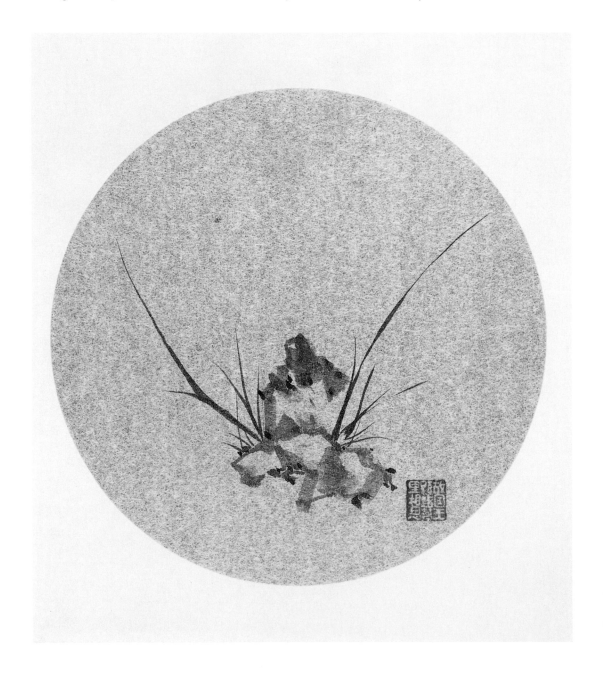

The image
of summer grass
is all that is left
of the warrior's dream.
(Basho)

Basic Form of a Rock

While a rock is a part of the mountain, it is also the mountain's basic component. Try to give spatial character to the basic shape.

It would be wonderful if you could give a three-dimensional quality to a stone with one swift stroke of the brush, because when a line is drawn with one brush stroke, you have given it strength and vitality.
Start by moving the brush, with the tip at an angle and with slight pressure, to the left. Follow through, ro-

Painting the basic shape of a rock

tating the handle between your fingers sideways and increasing the pressure while moving the brush upwards. When you reach the upper portion of the rock, pull the brush down, with the tip again at an angle, allowing the line first to become wider, by rotating the brush, and then narrower. As the brush is pushed sideways, the bristles will spread out and white spaces will be created. When painting a group of rocks, always paint the one in the foreground first and then those in back. If a rock is unevenly shaped and has particularly strong contours, start by painting a rough outline. Continue to paint with short, alternating, overlapping lines (called folding lines) that indi-

cate depth or shadows. A more compact line looks darker, indicating shadow. If necessary, emphasize part of the area by painting with the brush held at more of an angle.

Small dots added to folding lines represent moss growing on the rock. Dots painted close together will make the ink flow together, giving the surface of the rock a damp look, as if the whole surface were covered with moss. In general, the dots that indicate moss growing on the rock are used as accents or simply as decoration. If the dots appear hard and grainy, the stone will look rough. Make sure your painting conveys vitality, as well as tone and rhythm.

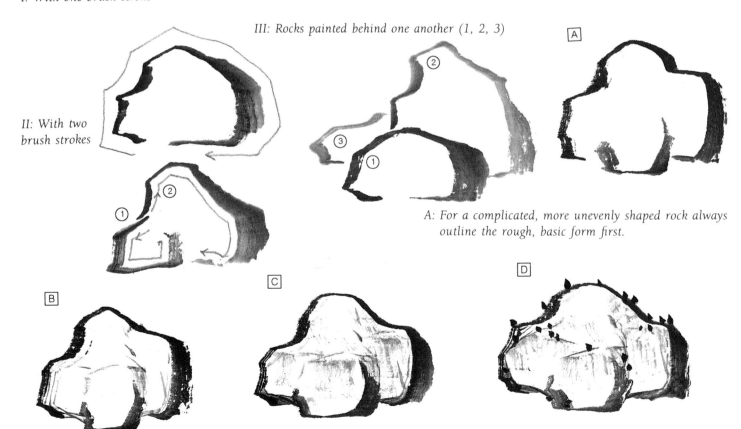

I: With one brush stroke

III: Rocks painted behind one another (1, 2, 3)

II: With two brush strokes

A: For a complicated, more unevenly shaped rock always outline the rough, basic form first.

B

C

D

B: Add structure.　　*C: Emphasize three-dimensional characteristics.*　　*D: Add dots for moss.*

The Classical, Imaginary Landscape

In northern China, where the climate is harsh, painting is clear, precise, linear, and rather objective. On the other hand, paintings from southern China, where light conditions are more favorable and humidity is high, are much richer in their nuances. The paintings appear more spacious with more differentiation in shadings. These paintings are much more lyrical and expressive.

The intention was to deepen the space by reducing the number of objects depicted in the painting and by creating more open space. Zen monks painted in this style.

Using the classical elements you have been taught so far, try to create a lyrical landscape from your imagination.

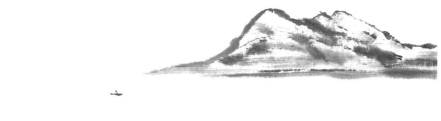

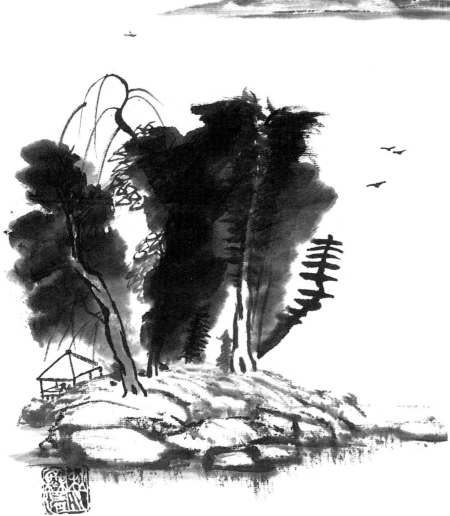

Space in a Landscape

In contrast to Western paintings, which have a perspective from one particular viewpoint, space in ink paintings is always viewed from several points. This is called the three-distance method. This method includes horizontal distances, from right to left or from left to right, the distance that represents depth, and the vertical distance from the top of the picture to the bottom, or vice versa. By examining the distance of a mountain from above and from below, the artist not only determines the height of the mountain, but also its volume.

The Composition of a Painting

Conventional paintings are created by dividing the area of the picture into foreground, middle ground, and background. It is an easy way for you to achieve depth and to create a natural spatial impression. But this is not the only rule of the game. You might leave out the middle ground. If your main interest is in the background, you can highlight it by using dark ink.

Once again, I want to emphasize that an ink painting is not necessarily meant to produce a naturalistic, realistic picture; rather, it is an attempt at finding the essence of an object or landscape, as well as your own personal perception.

You are walking—
how long the road is
and how green the grass
of the field.
(Buson)

For that reason, always start with that which represents your primary focal point. Of course, a painting will look more natural if objects in the foreground are larger and painted in darker shades, and objects in the background are smaller and painted in lighter shades. Ideally, contrasting objects in a composition should occupy the white space, which gives depth to the painting. Contrasting objects should also have a harmonious relationship to each other, literally and mentally; for instance, contrast between details and whole representations, between movements seemingly originating from and leaving the painting or coming from the outside and moving into the painting, and between primary objects and objects that are secondary, etc.

In my fantasy landscape on the page to the left, I painted the cabin first. I "sat" myself in the picture at a table, then I "planted" the trees and rocks and sprinkled sand over them. I concluded the painting by adding the seashore and the mountains in the distance.

Differences in Chinese and Japanese Ink Paintings

I am often asked about the difference between Japanese and Chinese ink paintings. The roots of Japanese ink painting go back to the fourteenth century. They came from China where, as already mentioned, two different styles already existed. These were the objective, distinct, and stylized lines of northern China and the subjective, lyrical, and expressive style of southern China. The latter style came to Japan together with Zen Buddhism. The Japanese aesthetic sensibilities are clearly expressed in these choices, as well as in the way *sumi-e* subsequently developed in Japan.

My Japanese teacher, as a way of introduction, was painting an orchid in absolute silence and extreme anticipation, using only a few brush strokes that were almost invisible. Another student, watching in amazement, exclaimed that it was difficult for her to describe the beauty she sensed in the painting. While only a hint of ink touched the paper the "breath" of the orchid seemed to touch our faces, quietly, delicately. The flower was only a shimmer of life on the paper, but the space surrounding it was like a large protective veil. The petals of the orchid became the center of the cosmos. It was an experience that gave me a sense of total happiness. All of us felt the beauty in the presence of that flower.

In contrast, the style used to paint that orchid was not what my Chinese master understood an ink painting should be. For him the orchid must be created in a clear, distinct form as required by Chinese tradition. For that reason, he made a pencil sketch to show me what the orchid looks like in nature. Even though stylized Chinese ink paintings are, to be sure, not realistic representations of nature, like a photograph, they are very naturalistic studies of nature. This is a style that has as its underlying concept a desire for idealization and does not necessarily depict nature in a problematic sense.

A German student proudly showed our Chinese master his painting which depicted a bare, dying pine tree on a mountain. The master immediately reached for his brush and painted needles on the branches, to show how strong and enduring the pine tree is. The student was speechless and then outraged that his depiction of the destruction of nature was discounted and changed. However, for the Chinese master, bound by his tradition, it was unthinkable that the pine tree, the symbol of long life, would shed its needles. He said, "No, what you painted does not exist. Did you ever observe something like it in nature?" This "observing with the intellect" is an objective attitude, as when a painter expresses in words many of the theories and principles that are to be adhered to when creating a painting. These theories and principles have been handed down to us. They exist in Chinese paintings, in contrast to Japanese ones, where observations are much more influenced by subjective feelings.

In addition to a more objective, logical depiction, Chinese ink painters also admire the clarity expressed in dynamic lines. If something is meant to be hidden, Chinese artists depict it in symbols, while Japanese ink painters often use symbolism or suggestive nuances of mood. Japanese ink paintings require a "being inside." When my Japanese master painted a flower, this flower was reaching out towards light, towards the open space, and the longing and reaching out would flow into the white space. My Chinese master was portraying what he was painting. When he painted trees, they would stand arrogantly against the white space, which they perceived to be a blessing from beyond.

When I looked at the painting *Trees in Daylight*, by the Italian painter Morandi, I was immediately reminded of trees as my Chinese master painted them.

Reflections in the Water

Ink paintings lend themselves well to painting reflections in the water, since water is part of the flow of ink. The white portion along the edge of the water, created by overlapping two brush strokes, gives the painting a sense of reality. What is fascinating to me is that the space appears to become really large through the repetition of the reflections, which seems to evoke feelings of eternity. This theme always reminds me of the paintings of water lilies by the French Impressionist Monet. In his pictures, just as in ink paintings, he was always trying to become one with nature. The reflection of the sky in his paintings reveals depth and eternity, which, even though it is painted in dynamic brush strokes, appears to me to be similar to the white space in ink paintings.

In contrast to Monet's wonderful symphony of color, ink paintings refrain from the use of worldly colors. Without color, the atmosphere of stillness and radiant peacefulness is intensified. Harmony in the painting is created by the asymmetrical balance of reality and illusion.

When painting a picture that contains reflections in water, start with the trees. Those that are close by should be larger and painted in darker shades than those that are farther away, which should be smaller and in lighter shades. Then paint the reflection of the trees in the water. While the ink is still wet, paint the shore and then the shoreline reflected in the water.

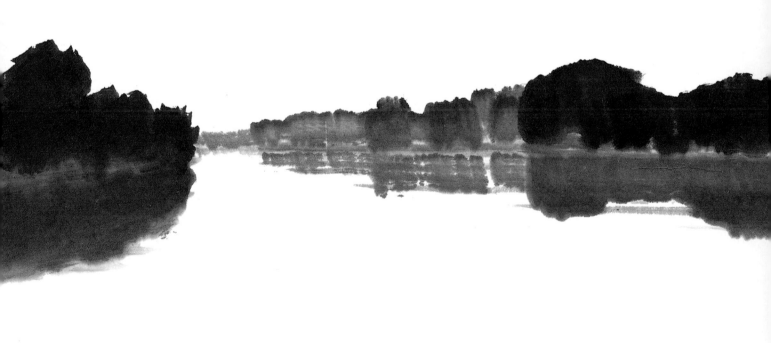

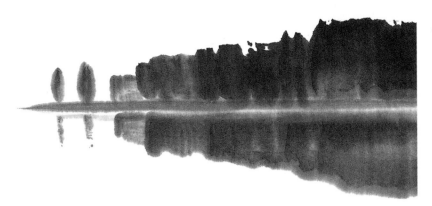

Reflection of trees in the water

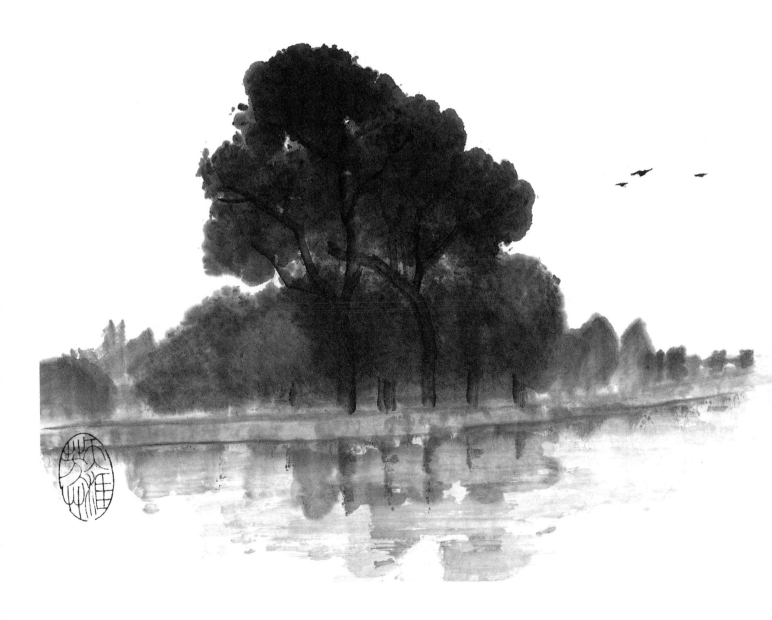

Snowscape

Snow, symbolizing purity and transitoriness, is a favorite motif for ink painters. Snow in a landscape is not "painted," of course. Rather, spaces are left unpainted and white. That which is not snow is painted. To avoid harsh contours, the wet brush, filled with three shades of ink, is guided along the edge of the snow with overlapping strokes. When using *Gasen-shi* paper, overlapping strokes prevent the harsh transitions often created by using different shades, transitions disliked by many artists. Paper with a high glue content, such as *Torinoko,* or watercolor paper, is ideal for achieving soft contours and gentle transitions between different shades, as well as transitions between painted and un-painted spaces. In the beginning, choose simple shapes for your snow landscapes, such as the one below, so that you become familiar with the technique. You should also experiment with different types of paper.

Snowscape

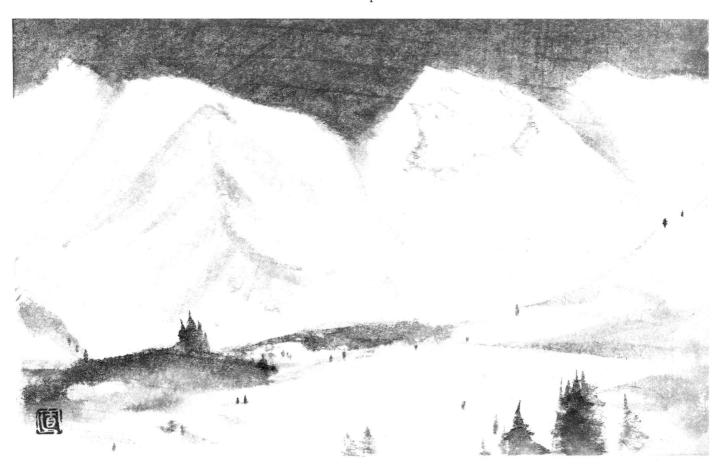

First snow

Snow-Covered Cabin

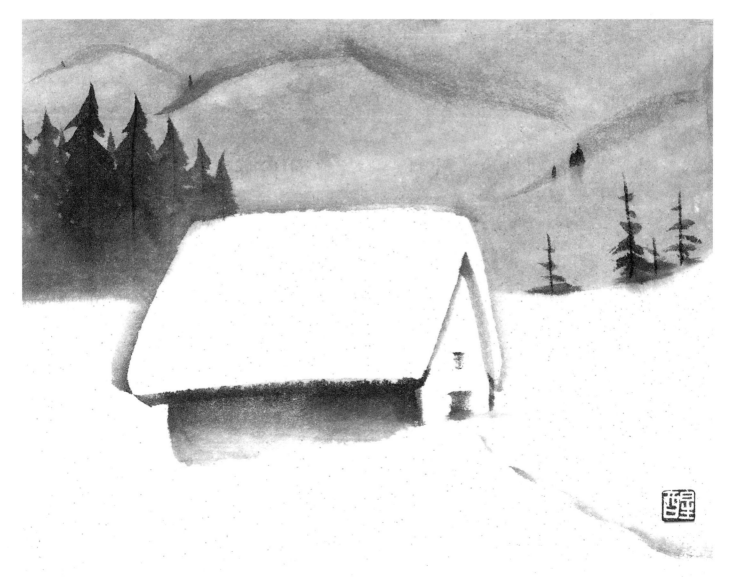

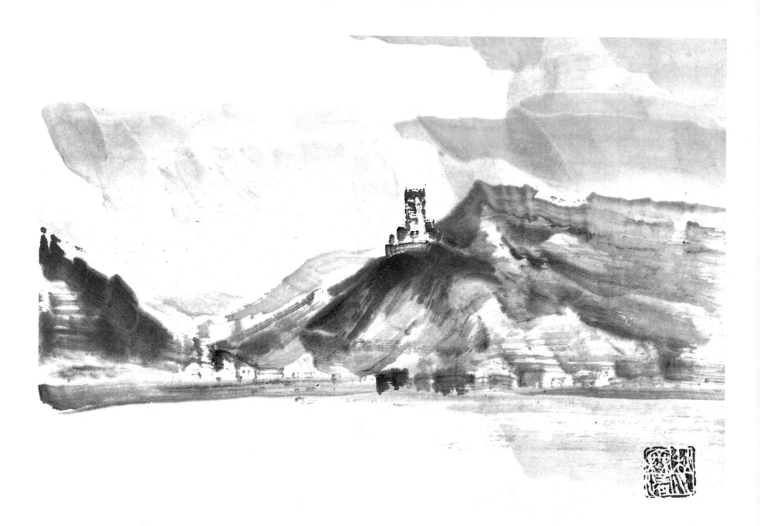

On the Rhine River

More Landscapes

I get very sad when I hear people say that bamboo and other so-called Oriental motifs are the best for ink paintings. Without question, bamboo trees and Chinese mountains are of great importance in ink paintings. After all, these motifs have always been a vital part of these paintings.

Nevertheless, why insist that Western landscapes or other motifs not be used in ink paintings? If you have sufficient experience, you might try your hand at a Western landscape. However, if you begin experimenting with Western motifs too soon, you might end up with pictures that look like Western-style black-and-white photos painted in ink with a pen. Your painting will be missing those fine nuances created by proper shading as well as the intuitive character of painting. Using Western motifs for ink paintings too early will not make them ink paintings.

From Sketching to Painting

Since ink paintings do not attempt to depict objects in photolike realism, you do not need to be totally occupied with the relationship between the size of objects or with light and shadow. Nevertheless, you need to have a clear idea of what you want to paint before you reach for your brush. Therefore, always make a sketch of your painting first. A sketch, compared with a photo, produces a much more intense and clear picture.

For ink paintings, it is particularly helpful to make a sketch first. This can be used as a draft or as a reminder. You are then free to follow your inspiration, because just one line in a sketch will determine if an object is a stone or a potato. The structure and the characteristics of an object must be clearly defined in order to paint in deliberate and determined brush strokes. Even more important is the enthusiasm and the positive attitude you bring to the process of painting and to the motif. Sketch only what has touched your imagination. Only then take a closer look and make more detached observations, capturing the essential character of the object.

Sketching an object will help in determining how you want to express your idea in your painting, how to divide the space and the movement within the picture, how to hold the brush, what the lines should look like, including how wide, long, and in what shading they should be.

Afterwards, think about what it is that you want to express. More often than not, a sketch will already

Nude sketch in chalk

have answered that. Then begin to simplify the form, reducing it to the absolute essentials.

Female Study

I am fascinated by the posture of the woman, particularly the open space surrounding the closed, and at the same time free-flowing, lines, beginning from below and flowing upwards over the back into the right shoulder. While my eyes follow the outline of the model, the chalk in my hand moves almost by itself. The lines appear on the paper, creating the shape of the body on the empty page. It is interesting to note that I moved the chalk as if it were a brush, sometimes vertically, sometimes at an angle, and even rotating it between my fingers. The lines on the paper are rich in nuances, sensual, dynamic, breathing. It is my hope that the lines express not only what I see but also what I feel.

Sketch of a dandelion

Dandelions

Dandelions blooming on a carpet of grass, cheerful and lively, like little children—this impression of simple and joyful life is what I want to express in ink. Before I even began to sketch the flowers, I knew exactly what they looked like and why the leaves had such an unusual shape. How extraordinary are those serrated edges of dandelion leaves! After I had painted the blossoms, I added the leaves, each one with a swift stroke of certainty. To add life to the plant, the smaller flower was positioned more to the left. I kept more white space on the right side.

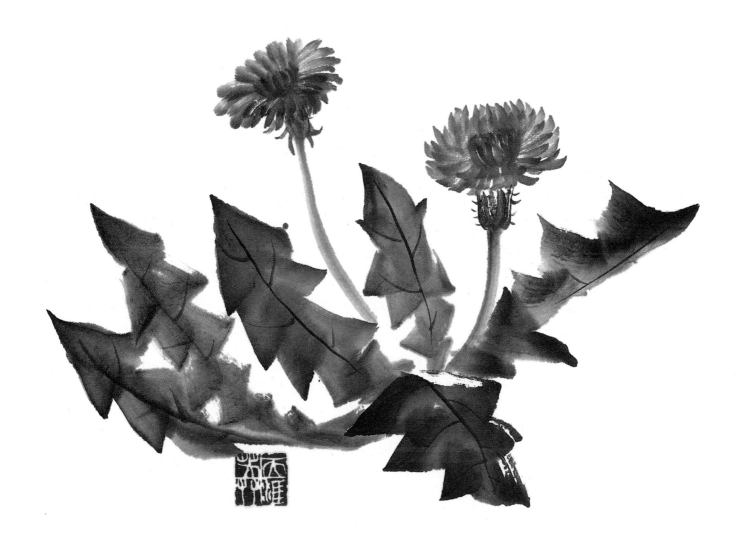

The Town of Heidelberg

I divided the space for this painting into the foreground with trees and a sloping incline, the middle ground with the buildings of the old town, and the mountain range in the background.

My intention was to create a contrast between the trees in the foreground and the old castle. In the beginning, I looked only at the castle, then at the trees and the mountain range, and finally into the distance far beyond.

I was imagining a love story, picturing the river, the ruined castle of a powerful ruler, all of it mortal. It is a motif that is as much a symbol of the past as it is of today.

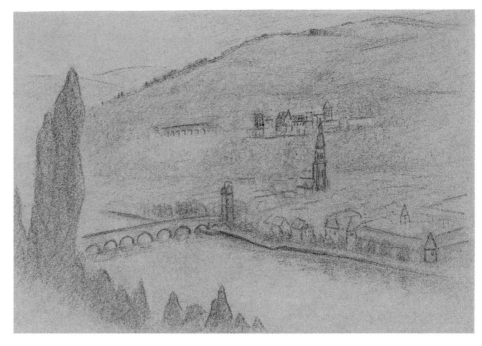

Sketch of Heidelberg

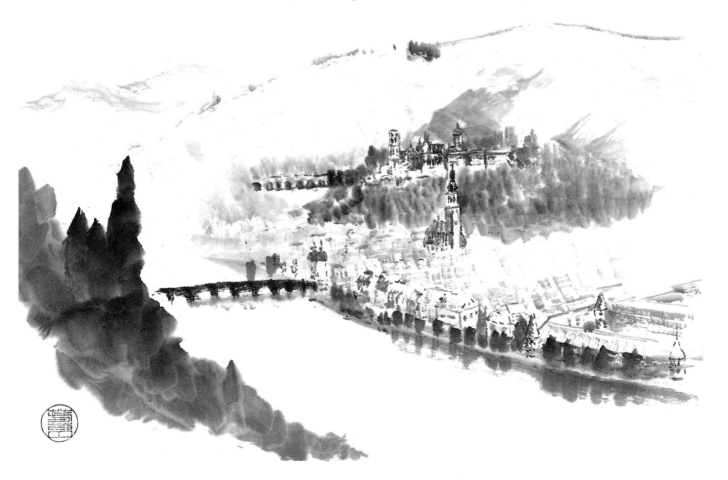

Gladioli

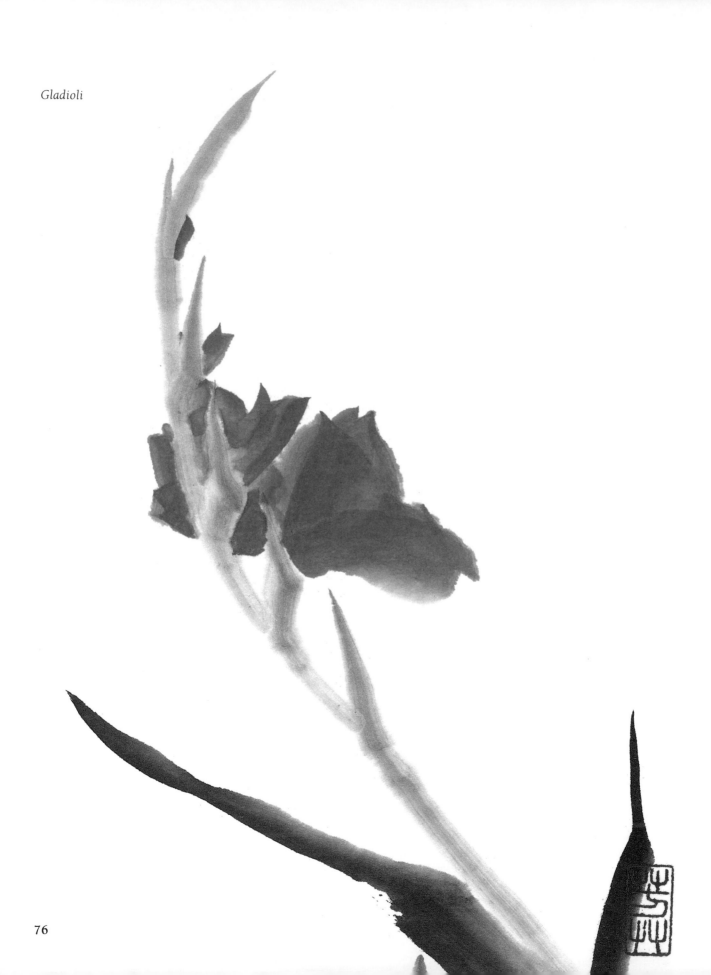

PAINTING WITH COLOR

The Role of Color

Ink paintings have been heavily influenced by Zen Buddhism. Ink, in its varying shades, replaces color. In other words, there is no "worldly" use of colored paints. Even though orthodox Chinese ink painters insist that the intensity of ink can express every existing color as well as light and dark, color has always been used in paintings, except in Zen works. Paintings that include color are only called ink paintings when ink is also used.

However, I believe that ink, with its peculiar characteristics, must play the most important role in a picture if a painting is to be called an ink painting. It is important that the color not be put on the paper in layers. Rather, it is used the same way as ink. In order to bring life to the painting, the lines should have a spatial quality.

In any case, if you use color, make sure the outcome is more beautiful than if you had done the painting in ink only. Ink and color should enhance each other.

If you paint pink-colored plum-tree blossoms, they should, when contrasted to the twigs and branches, appear even more delicate, more "fragrant" and graceful, and the branches should look even stronger and more lively, even if ink plays only a secondary role. A student who has been studying with me for some time told me that he feels more comfortable, more sure, and safer when he uses the "color" he creates with ink, in spite of the fact that, in the beginning, he did use conventional color in his work.

A painting done in ink

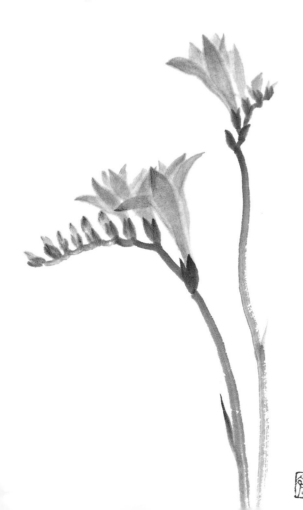

A painting done with watercolor

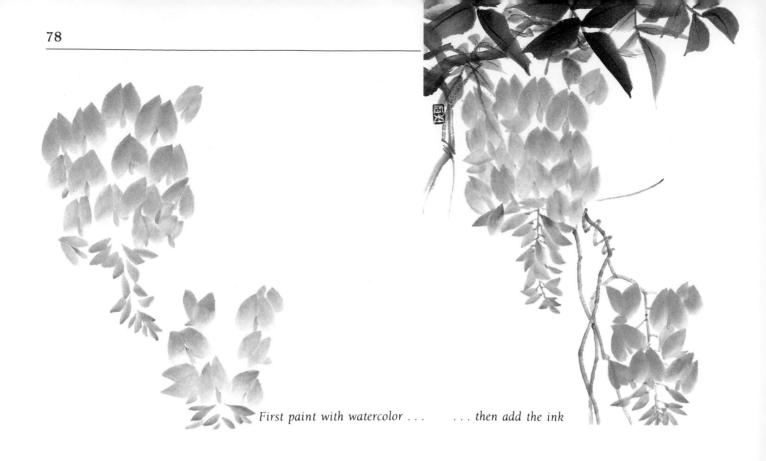

First paint with watercolor then add the ink

Which Color Is Appropriate?

Traditional watercolor inks are made by mixing colorfast pigments, as well as mineral and plant pigments and pulverized shells, with glue and water. For delicate shades, I recommend plant and earth pigments that are available in flake form or are sold in small containers.

Today, Western watercolor paints, *Gansai,* paints or Chinese watercolor paints are used. However, they are not waterproof. This often creates a problem when using the overlapping method or when the painting is being mounted. However, these problems can be eliminated by waterproofing the paints with a glue specifically made for this purpose.

Because of their somewhat loud color, I do not use either *Gansai* or watercolor paints. I prefer gouache and Western watercolor paints. Paper with good absorbing quality maintains the brilliance of both *Gansai* and Chinese watercolor paints better than Western paints.

It is perfectly okay to use normal watercolors that are sold in sticks or in liquid form. Color sticks, originally made from pure mineral pigments, today have several other components. You need a separate grinding stone made from porcelain for each color. The name "color inks" only means that they are waterproof.

Wisteria

If, as in the example above, the flower is the "main actor" and is to be created in color, paint it first. I used the following colors of gouache paint: cadmium red, ultra-navy

blue; cadmium yellow; and titanium white.

Both Western watercolor and gouache paints appear dull on absorbent paper. They lose much of their brilliance. However, if you have loaded the three different shades of color in your brush carefully and cleanly, your painting will still turn out very beautifully. During mounting (see page 90), some of the brilliance of the colors may be restored.

After you have completed the flower, use ink to paint the leaves. Follow this by adding the twigs with dark ink and the stems of the flowers with lighter ink. Use dry, strong lines. Add the stems that are winding around the twigs. When the leaves are almost dry, draw in the veins. To add vitality to the painting, you might want to paint little dots on the twigs. If you want to tone down the contrast between

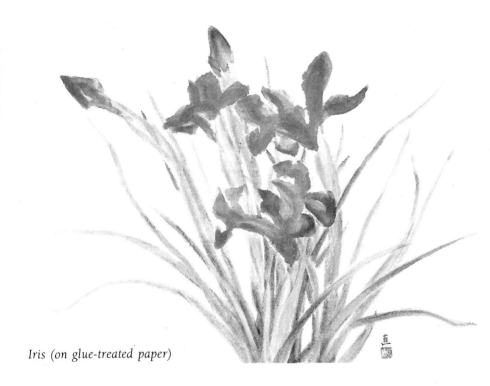

Iris (on glue-treated paper)

color and ink, mix a hint of color on the ink, or a hint of ink on the color.

Iris (on sized paper)

The picture of the iris was painted on sized paper. Gouache colors not only adhere better to paper that has been sized, they are also more lively; ink, however, loses some of its fine, subtle qualities.

Chrysanthemum

For the chrysanthemum I used a mixture that contained just a hint of ink and the following watercolors: carmine red, cadmium red, and cobalt blue. By adding ink to the watercolor and using *Gasen-shi* paper for this painting each overlapping stroke creates a white edge, giving the flower a three-dimensional appearance.

Chrysanthemum
(ink and watercolor)

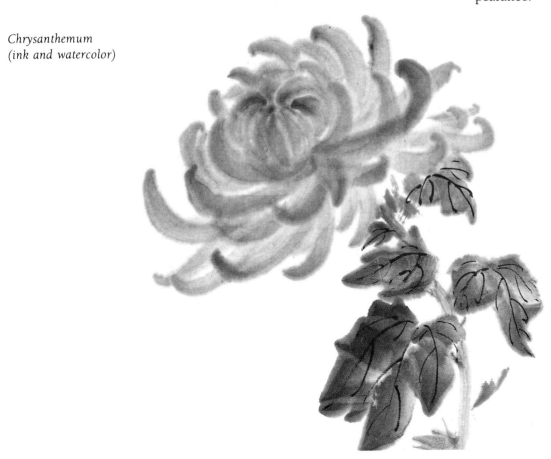

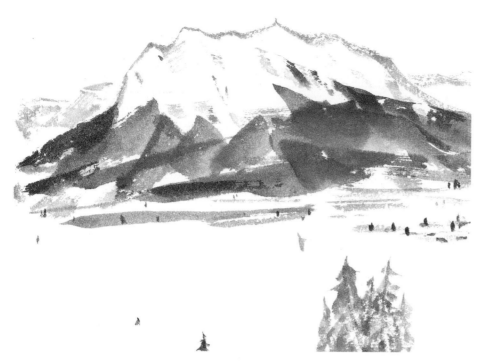

Mount Rubihorn in the Allgäu

If you want to assign major emphasis to the ink and use color only to enhance your painting, start by painting with ink and then with color. This sequence is necessary because when the color dries, the paper will become wavy, making it difficult to draw delicate lines and strong shapes. You can only work properly with three shades of ink when the paper is dry.

In this example, I first painted the foothills in broad strokes, adding the mountain range in the distance, and then the focal point, Mount Rubihorn. After I had successfully painted the foothills and the focal point, I added the pine trees in the foreground. Only then did I paint the accents with indigo blue.

First the ink . . .

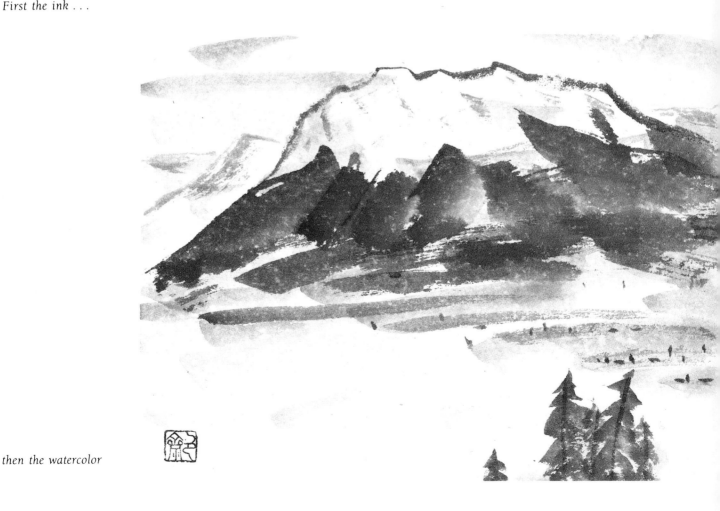

then the watercolor

I found it fascinating to observe how a few strokes of blue instantly turned the white, empty spaces into snow.

Lake Ammersee

In this picture of Lake Ammersee, I used color with a strong, broad brush stroke, after I painted the boat and the mountain in ink. The color expresses the diminishing warmth of the day against the cool breeze of the approaching evening.

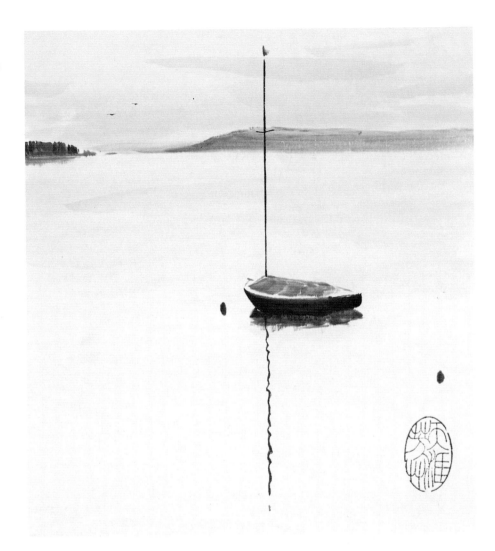

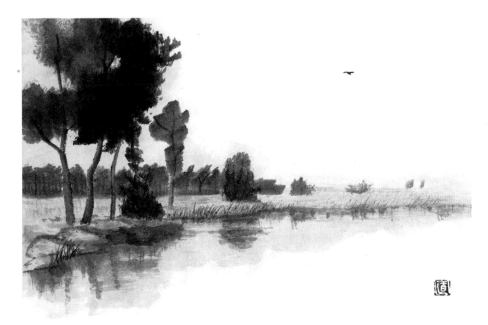

Stillness

For this picture I underscored the twilight mood at dusk by using highly diluted watercolors to create the space beyond the ink painting.

PRACTICE MOTIFS

What follows are examples of a few popular motifs. I have not included any directions. Try to paint them using what you have learned so far. Just let yourself get into the mood with the help of the accompanying text.

Cows

I saw these two cows on a meadow during a moment of absolute quiet. Only the sound of their ruminations betrayed their existence. They are such curious creatures, not easily intimidated. This picture comes alive because of the unity of the lines and spaces. The quality of the lines is an attempt to convey the heaviness of the cows. This composition is the result of the first impression I had when I discovered them.

Cat

Somebody pointed out to me that cats are a frequent motif in Japanese paintings. Might the reason be that the fur of so many is black and white? Or is it because they are loved? A cat in such a pose appeals even to me.

In her dream, the cat travels back to the very beginning of existence. The seal says, "Dreams are my home."

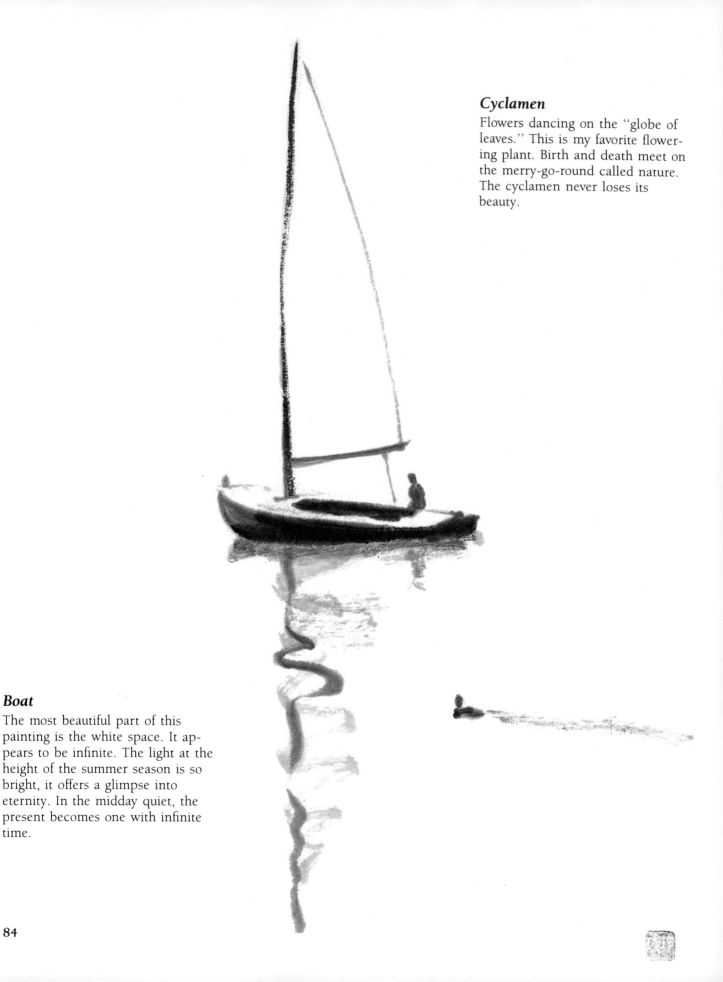

Cyclamen

Flowers dancing on the "globe of leaves." This is my favorite flowering plant. Birth and death meet on the merry-go-round called nature. The cyclamen never loses its beauty.

Boat

The most beautiful part of this painting is the white space. It appears to be infinite. The light at the height of the summer season is so bright, it offers a glimpse into eternity. In the midday quiet, the present becomes one with infinite time.

Abstract Landscape

Using Motifs and Materials Playfully

Abstract Landscape

As a child, my dream was to fly with the clouds. In this picture, I first painted the "direction" in which the clouds were moving. You may follow this by adding cumulus clouds with a wet brush whose edges are blended into the white space. Clouds come alive and "move" through the marks left by bristles that spread out.

Hatsuboku-san-sui *Painted on Watercolor Paper*

Hatsu means "pouring on," *boku* is "ink," and *san-sui* means "landscape," in a general sense; in the narrower sense, it means "mountain and water." *Hatsuboku* is a technique for subjective, spontaneous, and expressive creations.

Just as with the wet-on-wet method in watercolor painting, you begin by moistening and then pouring very light ink on the paper. After the paper has dried, you add other elements, such as mountains, birds, and trees, letting the ink used for them blend in naturally.

Hatsuboku *on watercolor paper*

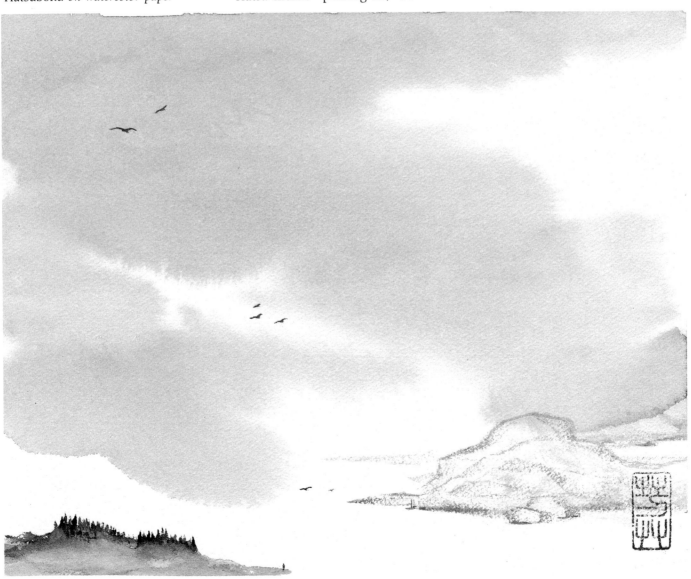

Farewell (painted on Shiki-shi *on a gold-colored background)*

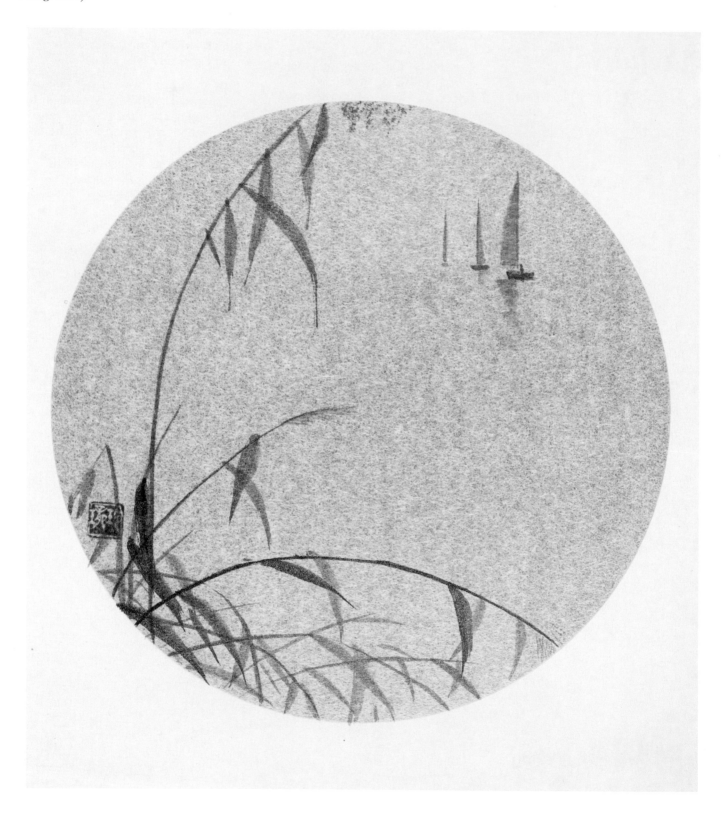

Farewell (on Shiki-shi paper)

This is a combination of classical and modern motifs. Many paintings done during the sixteenth and seventeenth centuries used paper covered with gold leaf. Even if the intent was purely to add a decorative touch, the effect of the reflection and the space seemingly bursting with brilliant light is truly enchanting. The image of eternity comes to mind.

Nude Brush Sketch

In a conventional sketch, the artist, when sketching a body on paper, usually uses many separate brush strokes. How different is this ink sketch! Here, almost in a single stroke, the brush moved from head to toe, turning alternately to the left and the right, and resting only temporarily on a few places to create the shape. The arm was painted with the second stroke, starting at the shoulder.

The brush "knew" how it wanted to be moved. The picture was finished in no time.

MOUNTING A FINISHED PAINTING

I am sure you have been disappointed when a finished picture looked different after the ink dried. If you worked with a lot of water, the paper, no doubt, became wavy. That is one of the characteristics of paper. It gets more or less uneven when it becomes wet, no matter how thick or thin the paper is. Grey tones seem to be duller after the ink has dried. Particularly when the differences in the shades of the ink are minimal, or when there is no dark ink anywhere in the painting, the painting looks lifeless. In other words, it does not look as nice as it did when it was wet.

Much can be corrected by mounting the painting on paper. In the process, the paper will be smoothed out, and "life" be restored. Mounting also protects the painting. These are good reasons for mounting a painting, even if the process seems to be cumbersome and time-consuming, an opinion shared by many. This is the reason framing ink paintings is a craft all its own, requiring special training, tools, and a lot of experience. In Japan, most artists bring their paintings to a specialty shop, because very few people have the courage to tackle it themselves. Everybody knows how easily paper can tear, particularly when it is still wet.

On closer examination, mounting a small painting is not all that difficult. After you have mounted a painting just once, and experienced the amazing improvement, you will undertake this job more often. Specialists know a lot of different methods for mounting a painting. However, for beginners, I recommend the following method. It yields good results.

Here is what you need:

1. *Paper.* Use an inexpensive, white, Japanese or Chinese paper. Under no circumstances should you use Western paper with a high glue content. The paper should be large enough to extend 1¼ to 1½ inches (3 to 4 cm) beyond the edges of the painting.
2. *Glue.* The best glue is wallpaper paste the same consistency as that used to prepare a wall.
3. *Brush.* Use a wide one with soft bristles to brush the paste onto the back of the painting.
4. *Brush.* This one will be used to press the painting on the paper. You may use a clothes brush, a paperhanging brush, or something similar.
5. *Spray bottle.* This is for spraying the painting with water. You can use an ironing spray bottle or a spray bottle used for house plants.
6. *Old cotton rags or paper towels.* These will keep your work area clean.
7. *A smooth surface.* This can be a windowpane or a mirror used as a surface for drying after the painting has been mounted.

Mounting Instructions

1. Place the painting facedown on a smooth and clean table.
2. Spray the back of the painting lightly with water from the spray bottle. Be careful! If the paper gets too wet, it will immediately become wavy, making it difficult for you to work with it.
3. Carefully lift the painting off the table and wipe off any excess water. Place the painting back on the dry table.
4. With the brush, apply the glue or paste to the back of the painting, starting from the center and working out to the edges. Apply a little pressure to smooth out any uneven, wavy spots.
5. Glue the supporting paper to the back of the painting. Take the supporting paper in your left hand and let it hang down. Hold the brush in your right hand. In order to center the supporting paper properly, let the first 1½ inches (4 cm) of the paper rest on the table and lower it slowly down over the back of the painting. Make sure that the smooth side of the

Dry, firm brush

supporting paper is glued to the back of the painting. Bubbles and any unevenness are removed by carefully tapping the bristles of the brush on the surface.
6. Lift the painting off the table, using the upper edges. If you have problems, slide a sewing needle along the edge. Hold the edge between your fingers as the paper comes loose. Before you put the painting back

on the table, make sure that the surface is clean. Apply glue to that part of the supporting paper that extends beyond the edge of the painting. Attach a paper loop under the edge of the supporting paper. This is used to lift the whole painting off the mirror or glass after it has dried. The paper should be 1¼ to 1½ inches (3 to 4 cm) long.
7. The painting is now glued to a glass or mirror for drying. Hold the painting by two corners, pressing the glued edges to the surface. Make sure there is sufficient air between the glass surface and the painting so that as the glue dries, the paper does not tear. If there is too lit-

tle air under the painting, lift the paper off carefully and let more air enter, or blow air into the pocket.
8. The painting may be dry within an hour; however, it is wise to let it dry overnight.
9. When removing the painting from the glass, lift it carefully by two corners. If it does not seem to lift off easily, slide the edge or tip of a knife under the paper loop (the one extending past the edge), loosening the paper around the edges from the glass surface. Glue and paper left on the glass are easily removed with water.
10. Remove the excess paper from around the painting with a paper cutter. If you want to frame the picture, leave enough of the supporting paper around the painting. This will make it easier to position the paper accurately when framing. It is not necessary to use passe-partout when framing a painting. Many times it is too heavy for a delicate ink painting.

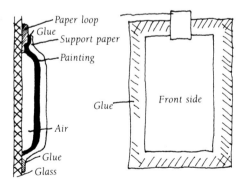

Paper loop
Glue
Support paper
Painting
Air
Glue
Glass
Glue
Front side

THE SEAL—THE ARTIST'S SIGNATURE

"Fragrant Grass" was the name given to me by my master. Nothing very special; most people think it is a weed, but it is a fragrant weed! Later on, he gave me the name "Little Elegance." This name and a seal were a gift from him. It was an exciting moment when he told me that he was about to choose my name, because this is the equivalent of a certificate bestowed only after the conclusion of a long apprenticeship. It means that one has successfully completed one's study and is ready to continue the journey as an artist. Additionally, I thought the name the master would give me would be an indication of how he saw me! Well, "Little Elegance" is also the title of the oldest collection of Chinese lyric poetry.

In ancient times, only rulers and institutions such as temples owned seals. It was not until the fourteenth century in China that individual artists, such as painters and calligraphers, used seals to sign their work. This practice was not begun in Japan until the seventeenth century.

The surface of the seal represents a small cosmos and, in a way, is a picture in itself. This picture often serves as an accent or a balance to the composition, existing in harmony within the painting. Very specific characters, so-called seal letters, are carved into the surface of conventional seals.

Since the end of the Zhon Dynasty, from about 300 B.C. until the middle of the sixth century A.D., a variety of seal letters was used. Today, there are no limitations as far as the choice of letters is concerned. For instance, the Japanese syllabary *kana,* as well as modern Chinese lettering and even Latin script, are in use today.

In the past, it was customary to produce white letters on a red background (negative) for official and institutional use and red letters on a white background (positive) for the signature of an artist. But even this rule no longer applies to an artist's seal. The surface of a seal may be square, rectangular, oblong, oval, or round. In times past, artists chose oblong seals with texts written vertically in the upper right side. Oval and round seals often contained congratulatory texts. Later, texts chosen by the artist, such as a line from a poem, were used. In the past, a seal not only identified the artist, but also the owner of the painting. When someone bought a painting or calligraphy, a seal printed on it identified ownership and was a sign of how much the painting meant to the new owner. It was a kind of signature. If a poem or praise was added to the painting, the person would sign his name as well as attach his own seal. Many famous paintings have a great number of seals printed on them, signifying how much they were appreciated over time by their respective owners.

If you want to create your own seal, look for a text that expresses your own personality. If you want to have several seals, you may do so. Choose the one that seems suitable for a particular painting, or choose a seal with a shape or size that will enhance the overall composition of the painting.

Since ancient times, the material used for seals has been collected from famous mountains in China, such as the *Juzan* or *Sheiden* stone. However, you can certainly use a simple soapstone or even a piece of wood.

The letters are carved with special knives that have two finished sides. However, you can also use an etching needle or a wood-carving knife.

The ink that is used has the consistency of thick honey. It is made from vermilion, certain oils, and plant fibres. The mineral pigments contained in the ink assure a beautiful, nonfading, durable ink with good adhesive properties. Because of the difficulty in producing it, the ink is not cheap. However, you can substitute other chemically produced paints or inks.

How to Carve a Seal

1. The surface of the stone must be smooth and even. If it is not, put a piece of sandpaper on a flat surface, hold the stone vertically, and move it over the sandpaper in large, circular movements, applying uniform pressure throughout.
2. The letters are carved into the stone in mirror image. This can be accomplished by copying them onto the stone from a piece of paper that has been turned right-side down.
3. The letters are cut into the stone with the carving knife. Make sure that the lines are not too

weak. Here, too, dynamics are appreciated. A balance between the carved and free space of the seal is important.

When the seal is finished, the seal maker deliberately "damages" lines and edges to make them irregular. This makes the seal appear to be old and venerable. Don't worry when your lines crumble a bit.

Where to Place the Seal

In general, a seal must never interfere with what has been painted. A seal is usually used in a place where you have tried to create movement and where the seal seems to flow into space. It may also be placed where an object in the painting needs a counterbalance in the space on the paper.

My Seals

1. "Little Elegance"
2. "Fragrant Grass"
3. "Naomi" (true, natural, beautiful)
4. "Fragrant grass in the distance"
5. "Little Elegance"
6. "Truth"
7. "Clarity"
8. "Something Different"
9. "The traveler is getting old quickly"
10. "The dream is my home"
11. "A colorful room"
12. "Sounds in the ink"
13. "Lonely Boat" (Loner)
14. "Even in the distance there is fragrant grass"
15. "Fragrant grass in the distance"
16. "Calmness makes change possible"
17. "Wake up"
18. "Fragrant Grass"
19. "A finished room"
20. "In the fall the water gets cold"

IN CONCLUSION

I wish this book could have been called *My Journey into the Art of Japanese Ink Painting*. By "My Journey," I mean mine and the one you undertook when you began. I often think it would be wonderful to have lived in the olden days, when tradition was still a constant part of our culture, when the Grand Master, a wise man as well as a grandfather, knew the road, and one could study for a whole lifetime. How strong and protected one would feel when surrounded by tradition! This is becoming clearer to me every day. I feel envy and jealousy because I allowed myself to leave my master much too early, finding myself very alone on this rocky road between East and West.

On the other hand, from my Chinese master I know the pressure can become heavy when an artist is bound by traditions. Five hundred years ago, Japan, unencumbered and free, had no tradition in *sumi-e*. Artists were free to employ and create something that became totally their own. Now, 500 years later, it is your turn. Be unencumbered and free. Since Western culture is so far removed from Japanese culture, it will be a bit more difficult for you to adapt to the Chinese culture than it was for us. But this distance might also have its advantages. You are freer to experiment because you don't have to be afraid of or be intimidated by the ink and the brush, and intimidated we were, from childhood on.

The goal is not to learn painting in the old style of Japanese ink painting, or the old or new Chinese style of ink painting. What I want to achieve is to be able to be proud of my artwork. That is what brought me to Japanese ink painting. This must be true for you, too. Reading and working with this book made us partners, together exploring the art form of Japanese ink painting. My hope is that this book has helped you to find an anchor. Presenting the ancient, traditional style of ink paintings in printed form could be seen as an affront against this venerable art form. Should anyone interpret it in this way, or if my efforts have not brought good results, Japanese culture has a way to forgive. If you meant well and tried your best, at the very least good will and the efforts expended remain.

In conclusion, I would like to thank all those who tolerated my blind enthusiasm because they were aware of my goodwill. Special thanks to Mr. Braun from Augustus Verlag, without whose engagement and advice, so patiently given, this book would never have come about.

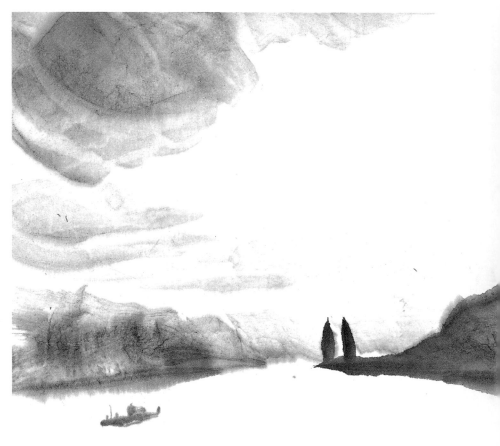

About the Author

—Born in Tokyo, Japan, in 1951.
—Studied painting, calligraphy, aesthetics, history of art, and literature.
—Studied under famous Japanese and Chinese masters of ink painting.
—Has worked with different techniques, both from the West and East (oil, watercolor, pastel, ink).
—Exhibited in Tokyo, Bonn, Münster, Nagold, Hamburg, Mannheim, and Dortmund.

—Since 1986, taught ink painting in more than 150 courses of Continuing Education for Adults (museums, community colleges, etc.).
—In 1987 and 1988, together with the Chinese master Li Geng, taught special courses in ink painting at the Institute of Art in Münster, Germany.
—In 1990 and 1991, taught ink painting at the Summer Academy in Wadgassen/Saarland, Germany.

Notes Concerning the Pictures

The preferred format for the rectangular pictures in this book is 9–10 inches (22–24 cm) and 14–15 inches (34–36 cm). Sometimes you can determine the degree of reduction by looking at the seal. All pictures in this book—even those that are shown in black-and-white—have been printed in color in order to show the nuances and exquisiteness of the brush strokes.

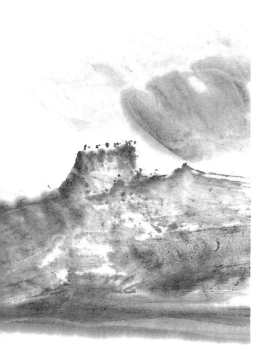

The Rhine River

INDEX